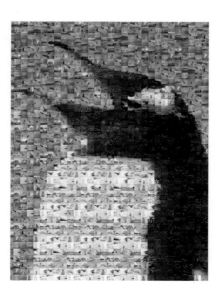

PHOTOMOSAIC PORTRAITS

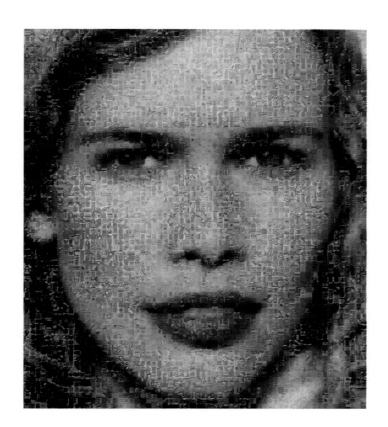

ROBERT SILVERS

Viking Studio

VIKING STUDIO
Published by the Penguin Group
Penguin Putnam Inc., 375 Hudson Street,
New York, New York 10014, U.S.A.
Penguin Books Ltd, 27 Wrights Lane,
London W8 5TZ, England
Penguin Books Australia Ltd, Ringwood,
Victoria, Australia
Penguin Books Canada Ltd, 10 Alcorn Avenue,
Toronto, Ontario, Canada M4V 3B2
Penguin Books (N.Z.) Ltd, 182–190 Wairau Road,
Auckland 10, New Zealand

Penguin Books Ltd, Registered Offices:
Harmondsworth, Middlesex, England

First published in 2000 by Viking Studio,
a member of Penguin Putnam Inc.

1 3 5 7 9 10 8 6 4 2

Photomosaic™ is a trademark of Runaway Technology Inc./
www.Photomosaic.com

ISBN 0-670-89348-X

CIP data available

This book is printed on acid-free paper.
∞

Printed in Japan
Set in Univers
Designed by Jaye Zimet

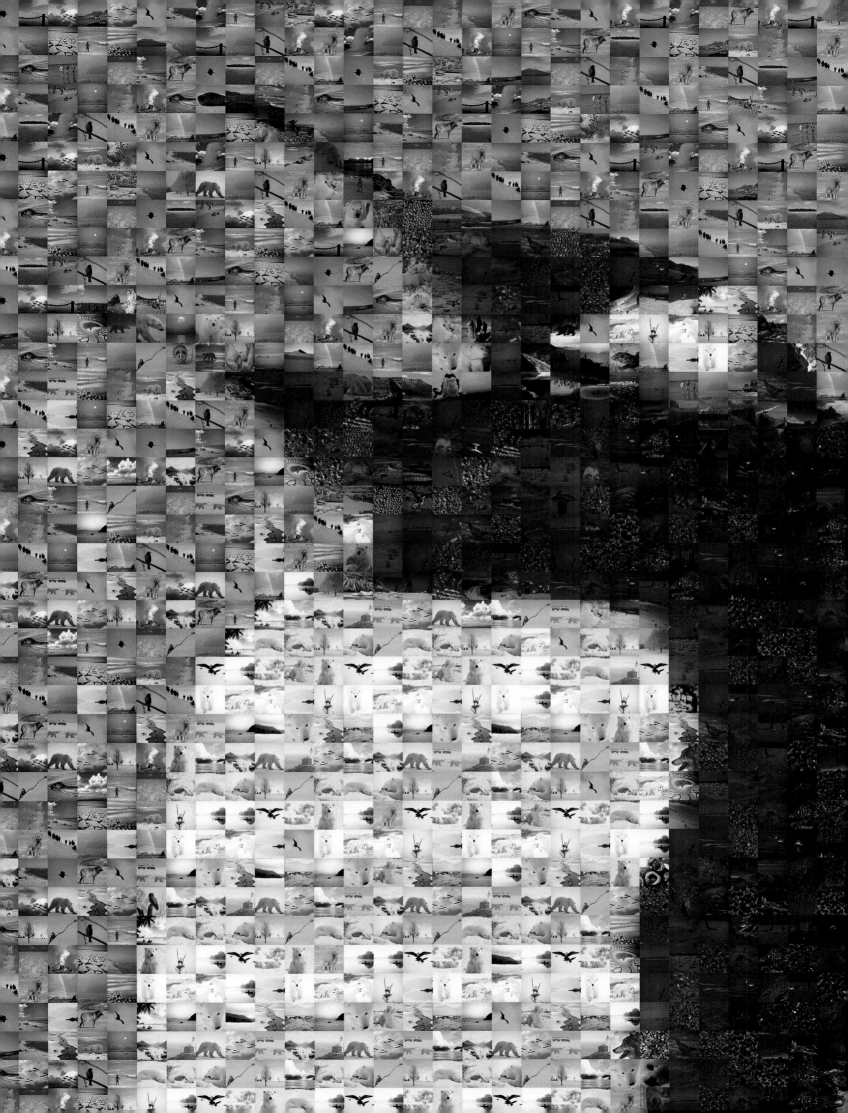

Contents

Introduction
ix

Jesus Christ
xii

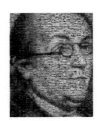

Benjamin
Franklin
4

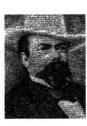

Jack Daniel
7

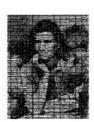

Migrant
Mother
22

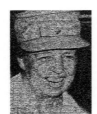

Eleanor
Roosevelt
27

Marilyn
Monroe
28

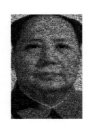

Mao Zedong
32

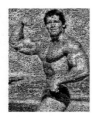

Arnold
Schwarzenegger
46

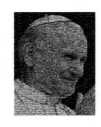

Pope
John Paul II
51

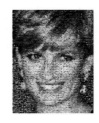

Diana, Princess
of Wales
52

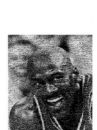

Michael
Jordan
54

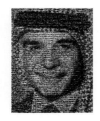

King Hussein
bin Talal
68

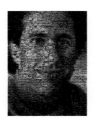

Jerry Seinfeld
71

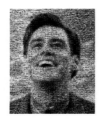

Jim Carrey
72

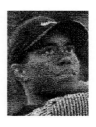

Tiger Woods
76

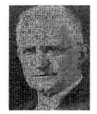

George
Eastman
10

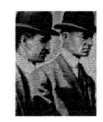

Wilbur and
Orville Wright
15

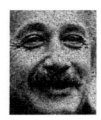

Albert Einstien
16

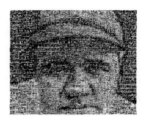

Babe Ruth
19

Jack Nicklaus
35

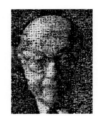

Ahmet M.
Ertegun
36

Richard M.
Nixon
40

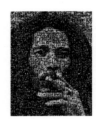

Bob Marley
45

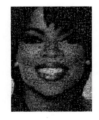

Oprah Winfrey
57

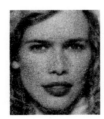

Claudia
Schiffer
58

Tim
Berners-Lee
63

Nolan Ryan
66

Randy Moss
79

Lara Croft
80

Introduction

I created the first Photomosaic when I was still a student at the MIT Media Laboratory. It was one of those once-in-a-lifetime moments. It happened when I saw a portrait made from hundreds of seashells glued to a board. The shells, carefully placed, formed an image of a face, *a portrait*. I thought to myself, "Hey, if you can construct a portrait based on the random variations in seashells, why not a picture made from hundreds of other pictures—photographs laid out like a tile mosaic." Of course, if you tried to do that by hand it would take weeks, if not months. But being at the MIT Media Lab, I thought it might be possible to write software that could do the job far more efficiently. The software would have to divide the master image into a grid, and then methodically sort through thousands of photos until it found just the right one to match each coordinate. In this way you could make a picture of someone, say, Marilyn Monroe, not with seashells, but with scenes from her life, or with other movie stars, or perhaps magazine covers.

I got lucky. The software actually worked, and it turned out to be an incredibly timely invention. It was May 1995, and graphical-computing power (in this case one of the Media Lab's SGI workstations) was only just becoming sufficient to handle such an enormous task. I had my machine, my software, and my raw material, so I felt confident enough to propose a photographic mosaic as my class project.

In the following weeks, I worked day and night at my powerful workstation (still powerful today, but would cost less than the $250,000 it cost then), ironing out the bugs until the very first image magically emerged. It was a portrait of my friend Julia Ogrydziak made from animals, nature, scenes, and any other image I could lay my hands on.

After that I worked like a man possessed. I created more portraits. The first was an image of former MIT President Jerome Weisner that the Media Lab used in its gorgeously printed newsletter, *Frames*. *Frames* went to a mailing list that included the press and corporate and scientific leaders around the world. One person who saw the Photomosaic was an editor at *WIRED* magazine, and I got my first professional commission—a cover portrait of Media Lab Director Nicholas Negroponte.

Then the Stock Market Photo Agency in New York commissioned me to create an image of the Statue of Liberty for the cover of its new catalog called *American Mosaic*. Again, this was sent to exactly the right people—art directors and photo editors who buy artwork for magazines and corporations across the country. Then the most amazing thing happened. I got a telephone message from Mimi Park at *Life* magazine. I couldn't believe it. *Life* magazine calling me, a student? To do the cover of its sixtieth-anniversary issue? Incredible. As someone with a lifelong passion for photography, it was a dream come true. Mimi and I discussed making an eye, a camera, and a globe, but in the end I suggested a portrait because a portrait would have the best chance of success.

This has a demonstrable scientific basis. It's very important for humans to be able to differentiate minute variations in the human face so we can recognize friend from foe. We can do this almost from birth. Even infants can recognize their mothers. Perhaps as a consequence, we see faces

everywhere: on the moon, in clouds, even in the bark of a tree. This helps people recognize that photographic tiles, or in this case, *Life* magazine covers, form an overarching image. But whose image would we choose? We decided it should be Marilyn Monroe—one of the most recognizable faces on earth and someone who had already appeared on the cover of *Life* twelve times. I spent months testing various ways of arranging *Life* covers into a portrait of Marilyn, and each test took hours to crunch. Eventually, however, Marilyn's form developed as if by magic. Anyway, it was magic to me—and the cover was a huge success.

After that, the work came fast and furious. The Library of Congress commissioned a portrait of Lincoln. Penn and Teller, my favorite magicians, commissioned private portraits. Vice President Al Gore visited and wanted a portrait. Lucasfilm wanted pictures of Yoda and Darth Vader made from *Star Wars* images, and a friend of Microsoft Chairman Bill Gates asked me to make Gates a fortieth-birthday portrait. Then MasterCard asked me to create a portrait of George Washington from five-thousand credit cards. All of this happened while I was still a student, and it started to affect my schoolwork. It was kind of hard to concentrate on my studies when TV crews from *Dateline NBC* kept showing up.

To accelerate my graduation, I made my Photomosaic class project my master's thesis. In June 1996, I graduated from the MIT Media Lab. The next day I founded Runaway Technology. I called it Runaway Technology because I hoped my creation would spin rampantly out of control. My wish came true. Since I started Runaway, hundreds of magazine, newspaper, and television shows have featured Photomosaics, and this in turn has generated more commissions than we can possibly handle—all without any advertising or solicitation of any kind.

I think Photomosaics have caused a strong response because they embody meaning on two levels. These two levels of content can have either a direct relationship, such as a portrait of Lincoln made with Mathew Brady Civil War pictures, or an ironic relationship, such as a Mona Lisa image I once made from photos of plumbing fixtures. This makes for a rich medium that compels people to stop and pay attention.

More than anything else people ask me whether Photomosaics are an art or a science. I tell them that Photomosaics, like any art in formative stage, has elements of both. Take painting or photography. In the beginning, both were developed by scientists. Later, artists used them as a means of expression. The art of photography was always my first passion, and the science of computers came later, but every chance I get, I try to combine these two interests, and that resulted in the new medium of Photomosaics. In both photography and Photomosaics, my favorite subjects continue to be portraits. I guess it's the primal urge to recognize and depict faces. That, in turn, has led to this book—a collection of my favorites. I hope you enjoy each one.

I wish to thank David Cohen, who has been a wonderful editor, agent, and guide through my journeys, and Corinne Nagy and Pamela Forbes for helping me to organize this book. Thanks also to everyone at Runaway Technology for the success of our organization and the wonderful team at Viking Studio Books for making this book possible.

Robert Silvers
Cambridge, Massachusetts
April 2000

Jesus Christ

Robert Silvers created this image for a contest sponsored by the *National Catholic Reporter,* which requested participants to create fresh images of Jesus Christ for the two thousandth anniversary of his birth. Silvers's depiction of Christ, titled *Christ II*, is composed from fragments of the Dead Sea Scrolls, a body of six hundred manuscripts written in ancient Hebrew and Aramaic that were discovered in 1947 by a shepherd boy in caves northwest of the Dead Sea. These leather and papyrus scrolls, created between 200 B.C. and A.D. 100, are roughly contemporaneous to the historical Christ. They contain hymn books, biblical commentaries, apocalyptic writings, and sections from every book in the Old Testament except Esther.

Until recently, scholars had to travel to the Shrine of the Book, the Rockefeller Museum in Jerusalem, or to the Museum of the Department of Antiquities in Amman, Jordan, to view the largest collections of the scrolls. Now, however, universities are posting downloadable digital images of the Dead Sea Scrolls on the Internet. This recent innovation made this Photomosaic image of Christ possible.

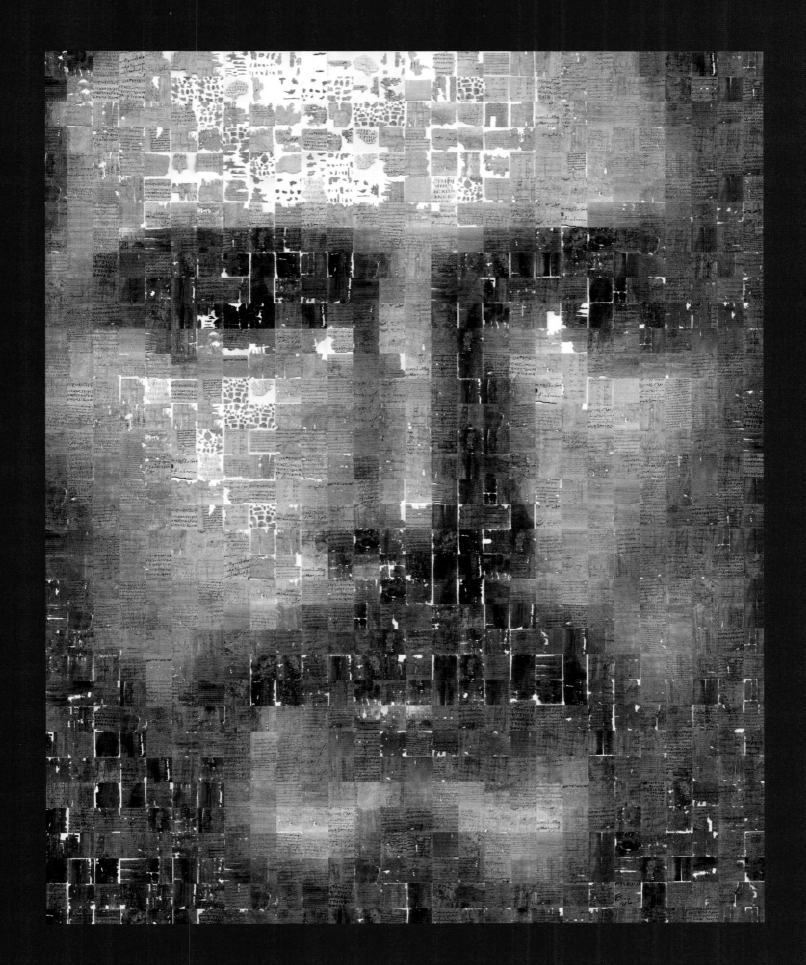

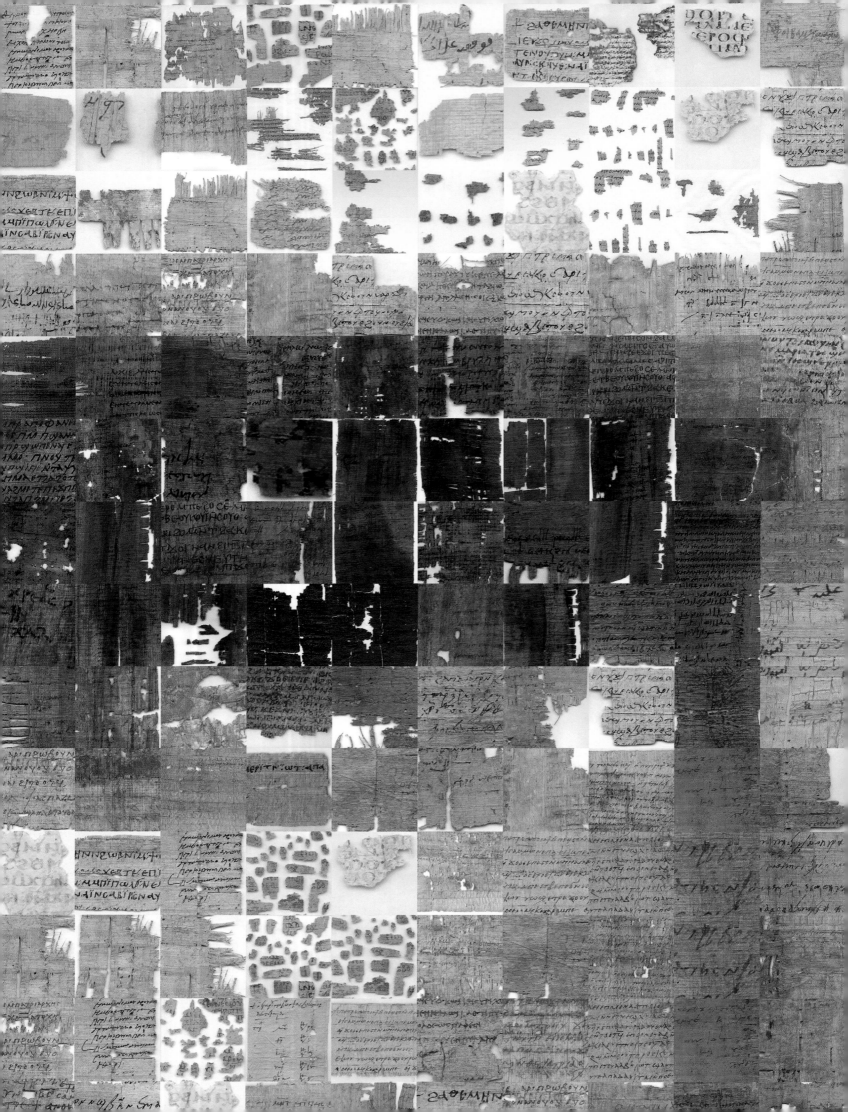

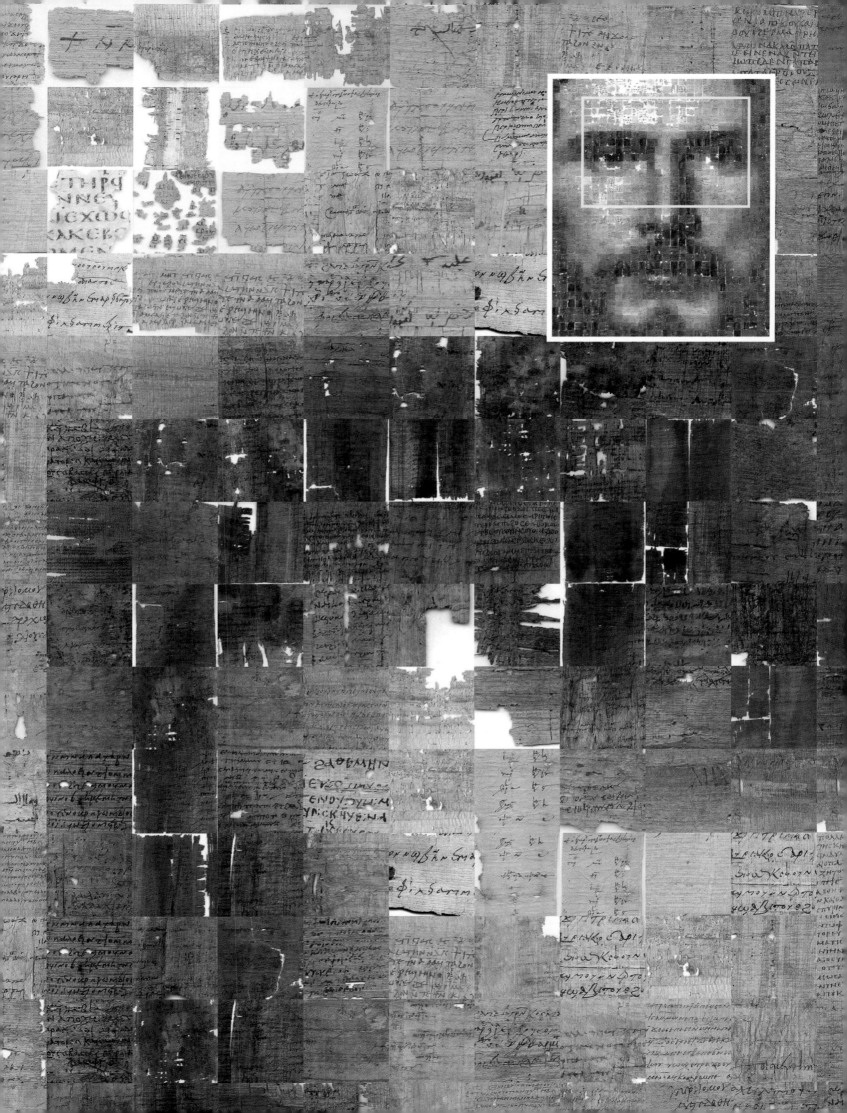

Benjamin Franklin

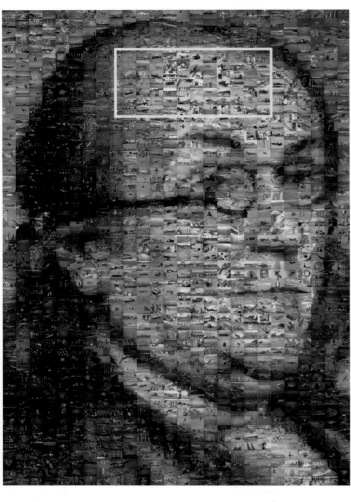

Founding Father Benjamin Franklin rose from humble beginnings to epitomize the notion of Yankee enterprise and ingenuity. Franklin's role in drafting the Declaration of Independence and the U.S. Constitution is well known, but he was also a printer, writer, scientist, and inventor. The prolific Franklin proved that lightning was electricity and invented the lightning rod, bifocals, and the odometer. As a social architect, he started the first fire company, organized the Philadelphia police force, and founded an academy that eventually became the University of Pennsylvania. It was this last accomplishment that led *American Benefactor* magazine to commission a Photomosaic cover of Franklin for its 1997 issue, featuring the Benjamin Franklin Awards honoring the "100 Most Generous Americans."

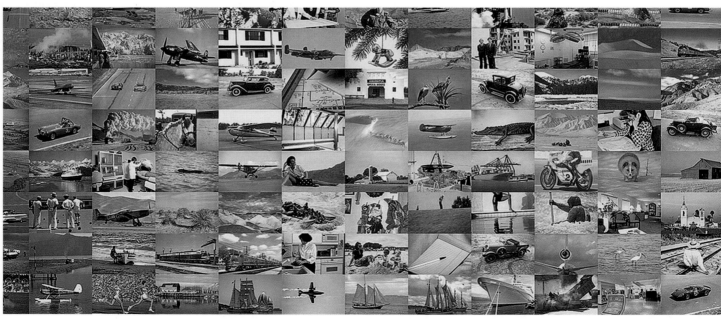

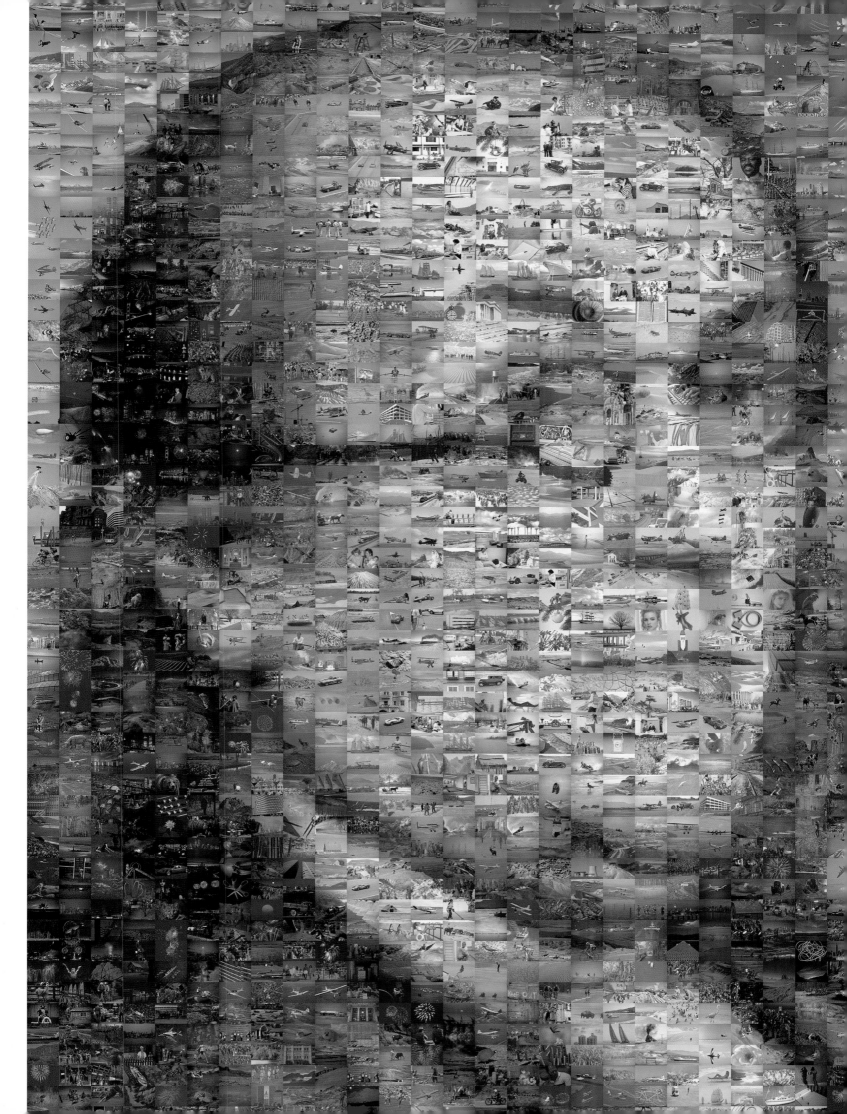

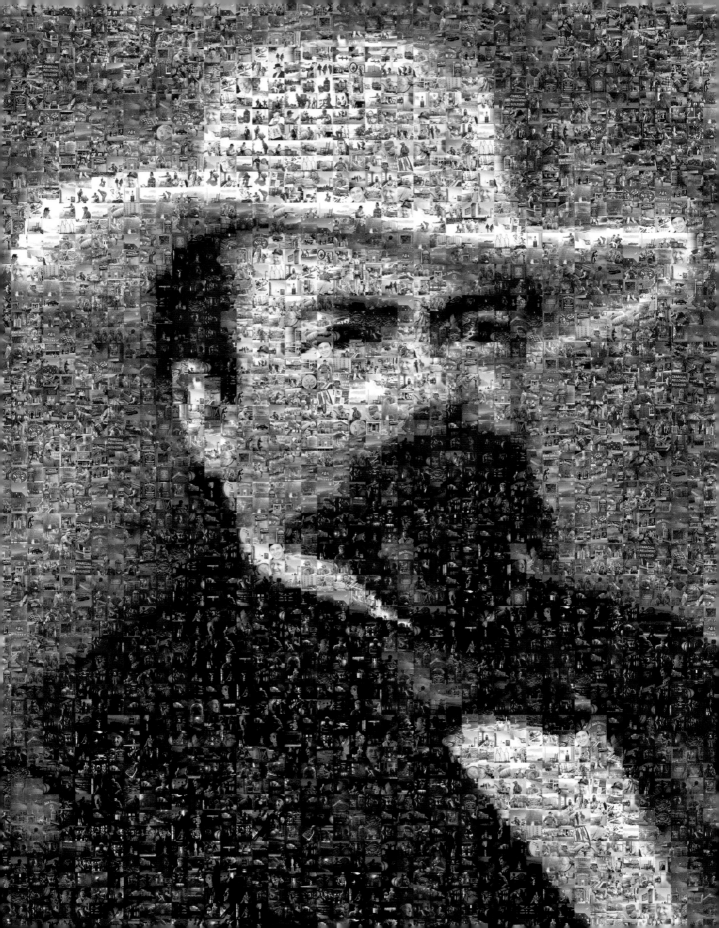

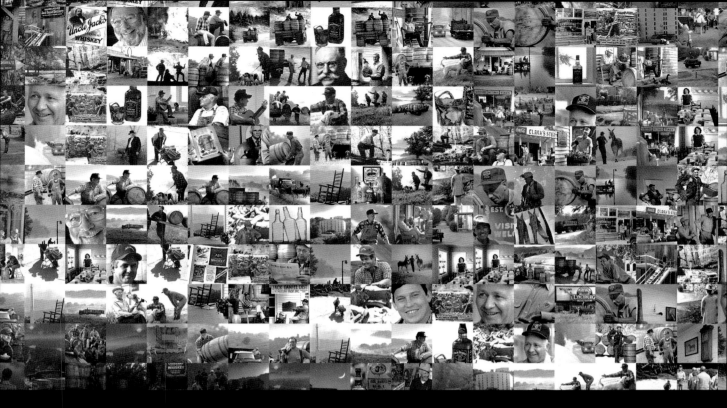

Jack Daniel

WHISKEY DISTILLER

Born in 1850, Jasper Newton (Jack) Daniel established his world-renowned distillery in Lynchburg, Tennessee, when he was only seventeen years old. Having perfected a slower and more expensive process of mellowing fresh whiskey through hard-maple charcoal, Daniel was among the first to register his distillery with the government.

In 1999, Brown and Forman, owner of the Jack Daniel's brand, decided to celebrate his one hundred and fiftieth birthday by commissioning a Photomosaic portrait of "Mr. Jack" comprised of photographs from the company's archive. This image was eventually used to celebrate Daniel's birthday around the globe.

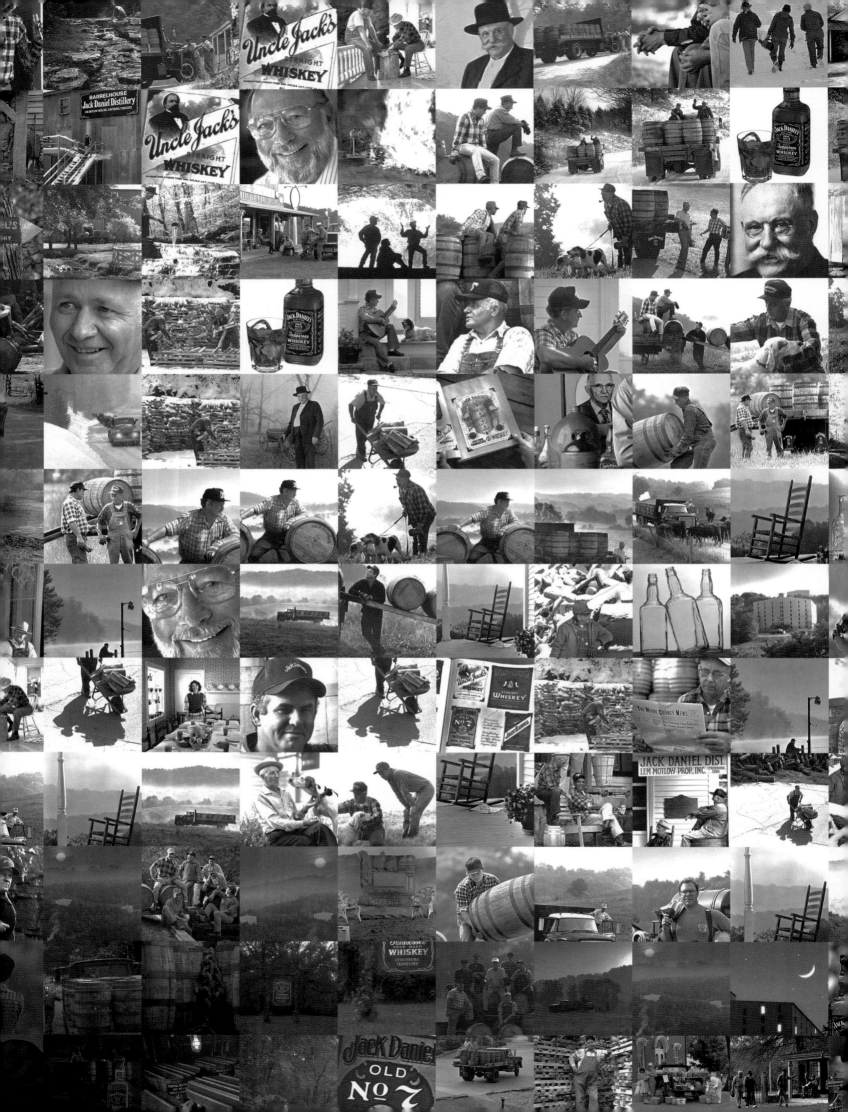

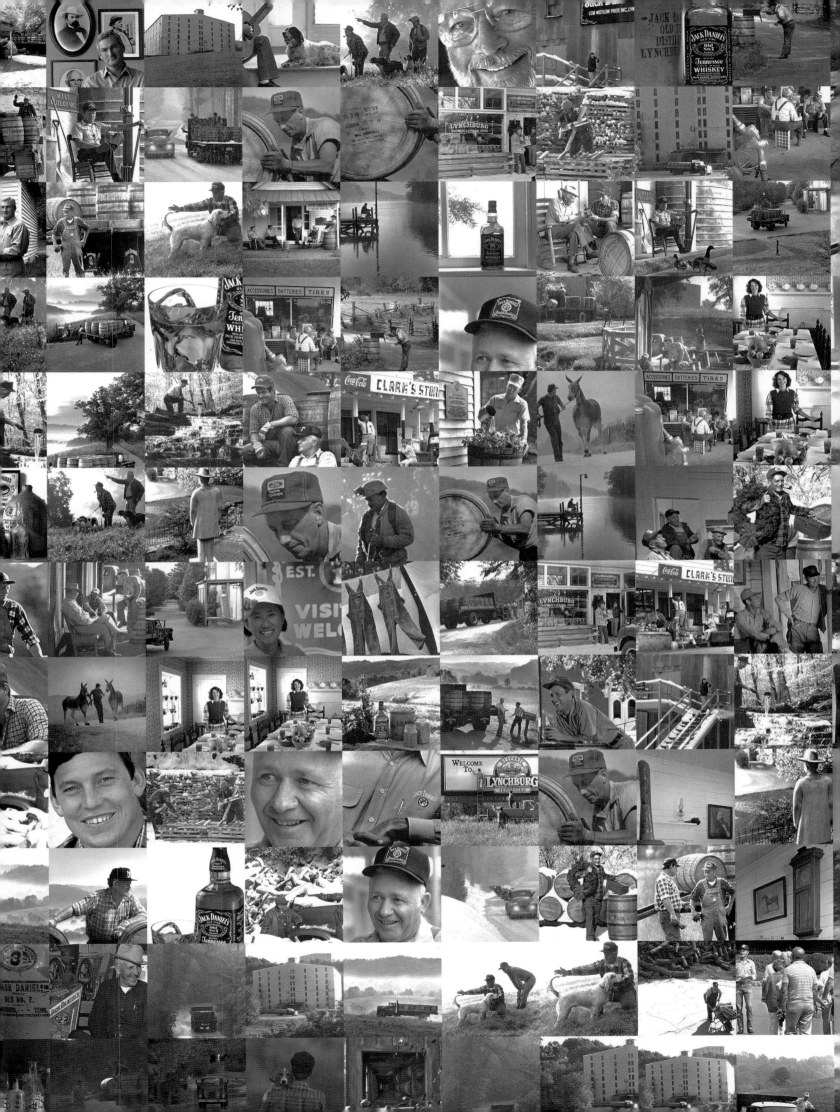

George Eastman

The prolific George Eastman invented processes for dry-plate photography, color photography, flexible roll film, and, of course, the Kodak box camera. In 1892, he formed the Eastman Kodak Company that introduced the legendary Brownie camera eight years later. These innovations brought photography to the masses, making Eastman a seminal figure in our modern, image-based culture.

In 1949, Eastman's Rochester, New York, home was turned into the George Eastman House International Museum of Photography and Film. The museum includes Eastman's restored house and gardens, an archives building, research center, galleries, two theaters, and an education center. Eastman House commissioned this Photomosaic portrait to celebrate its fiftieth anniversary. To create this image, the museum gave Robert Silvers more than fifty-thousand images from its historical-photography collections. Out of respect for these classic images, Silvers did not crop any photos when creating the Eastman portrait; they are reproduced with all their borders and sprocket marks intact.

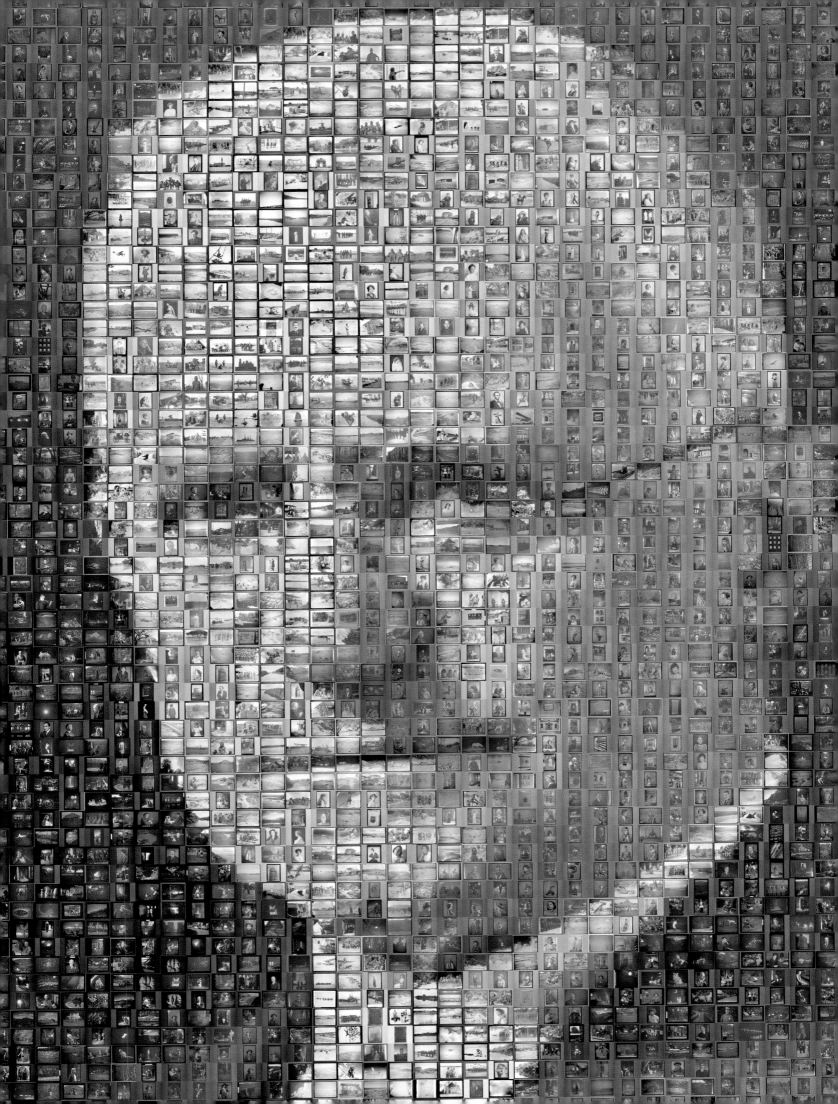

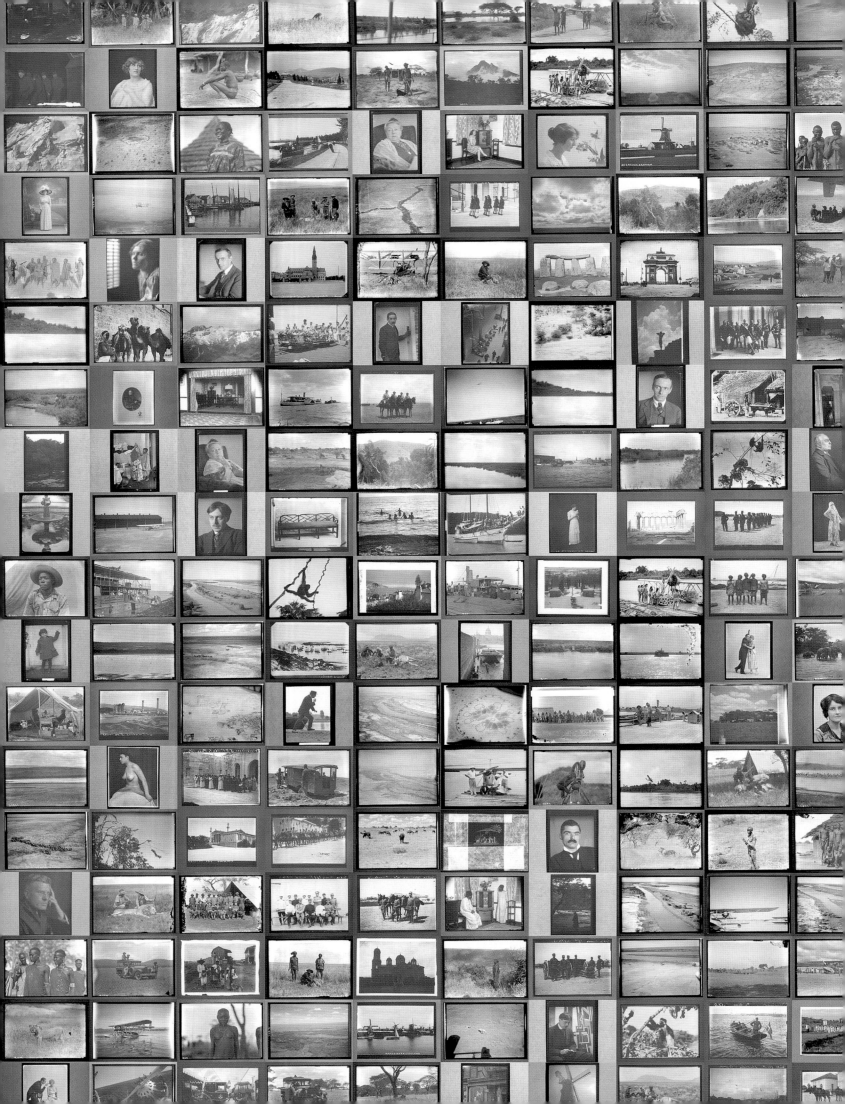

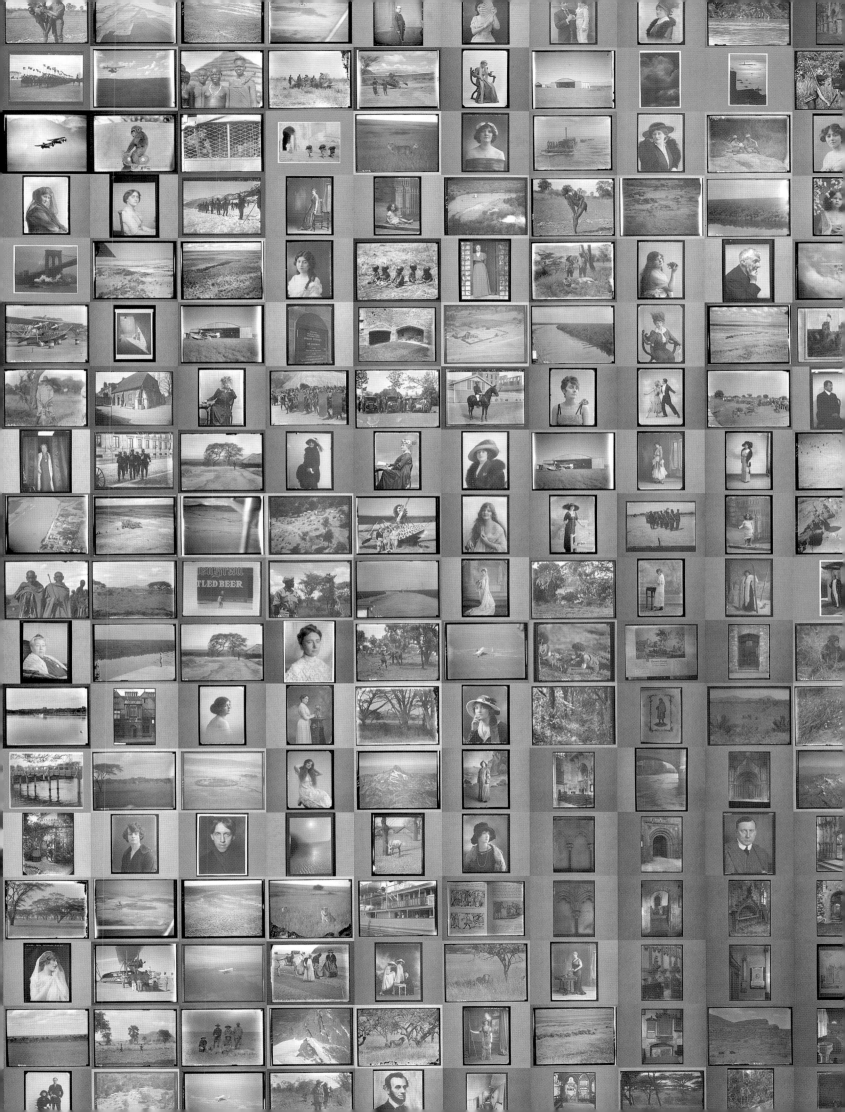

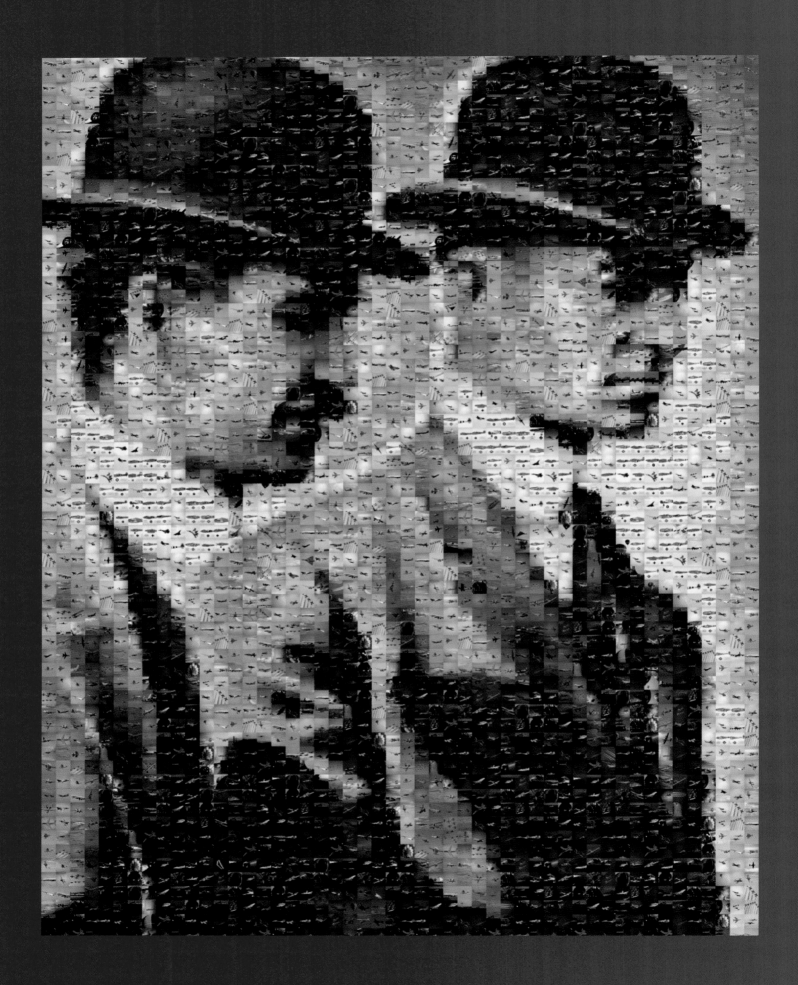

Wilbur and Orville Wright

INVENTORS

Wilbur and Orville Wright figured out how to control the roll, pitch, and yaw of a heavier-than-air craft—and thereby "invented" the airplane. From their early efforts in 1899 until their first successful flight in 1903, the Wright Brothers applied teamwork, scientific method, and immense perseverance toward their goal. They pored over every available bit of aeronautical research, experimented with kites and model gliders, and built a sophisticated wind tunnel where they tested up to two hundred different wing shapes. On December 17, 1903, Wilbur Wright struggled to control the fragile Wright Flyer as it flew 852 feet into a 21-mile-per-hour wind on North Carolina's sandy Outer Banks. When Wright landed, after only 59 seconds, man had conquered the air and entered a three-dimensional world of promise and possibility. Silvers's Photomosaic of the Wright Brothers—created for this book—is comprised of a great variety of historical and contemporary aircraft from early biplanes to the Blue Angels.

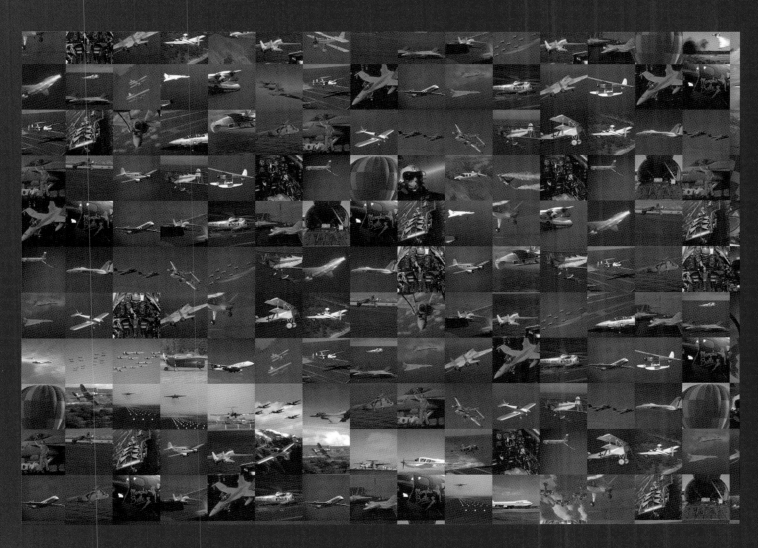

Albert Einstein

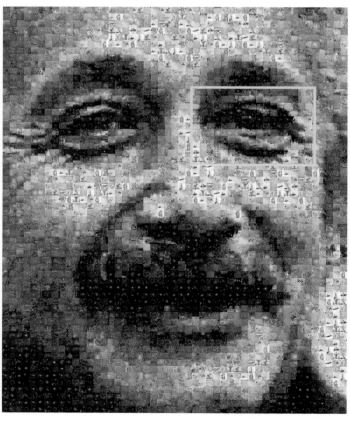

Everyone associates Albert Einstein with his theory of relativity, but when he won the Nobel Prize in 1921 it was for the work he had done in 1905 on the electromagnetic radiation of light! Einstein's brilliance and vision encompassed a range of fields from theoretical physics to classical mechanics, statistical mechanics, electromagnetic effect, and quantum theory. In addition to his scientific contributions, Einstein was a champion of peace and has been viewed as something of a mystic. Considered the greatest thinker of our time, he was chosen as *Time*'s "Man of the Century" in the year 2000. Robert Silvers constructed this portrait with general scientific images culled from Silvers's collection of more than 500,000 digitized pictures.

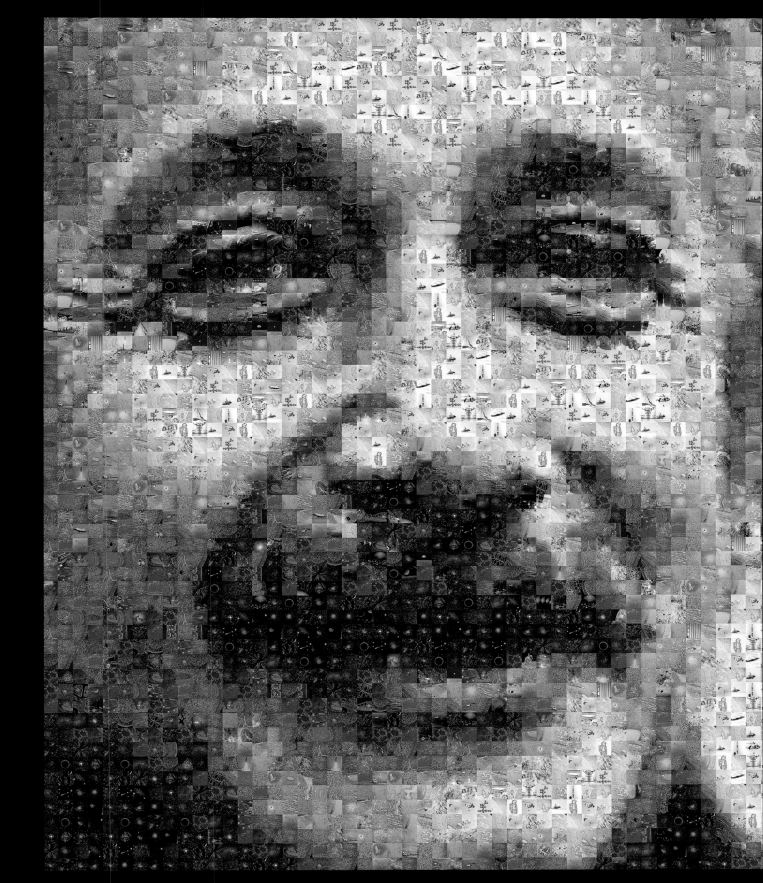

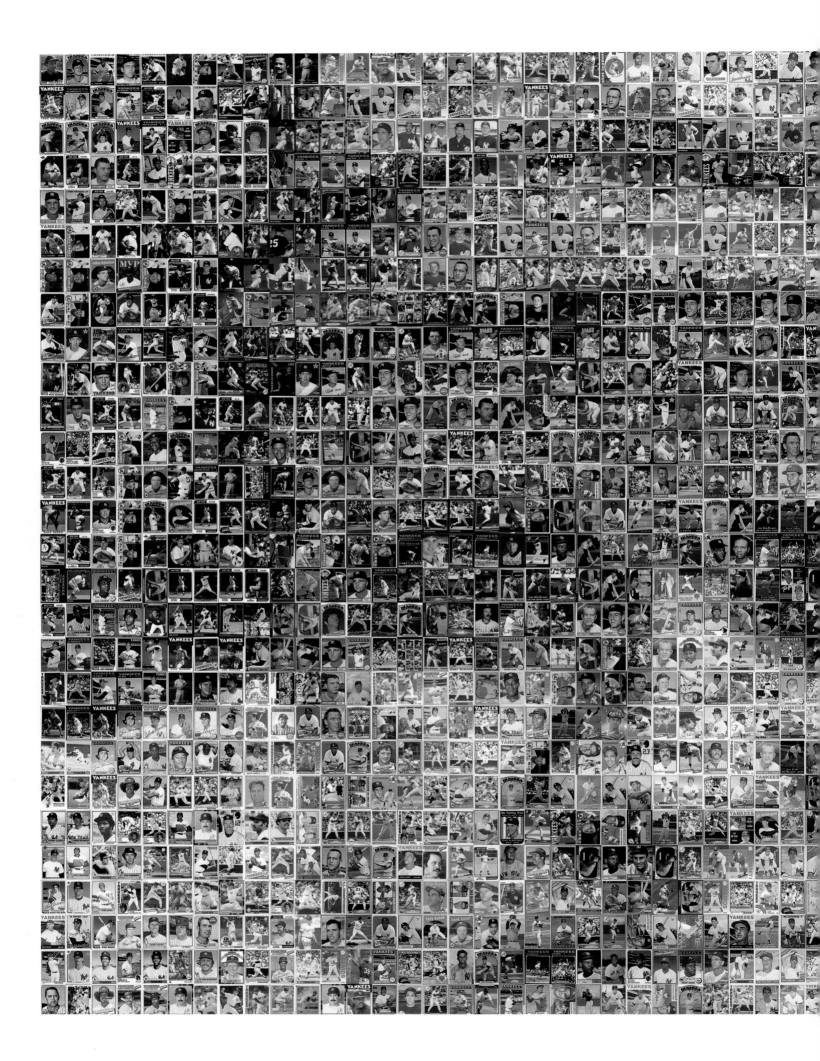

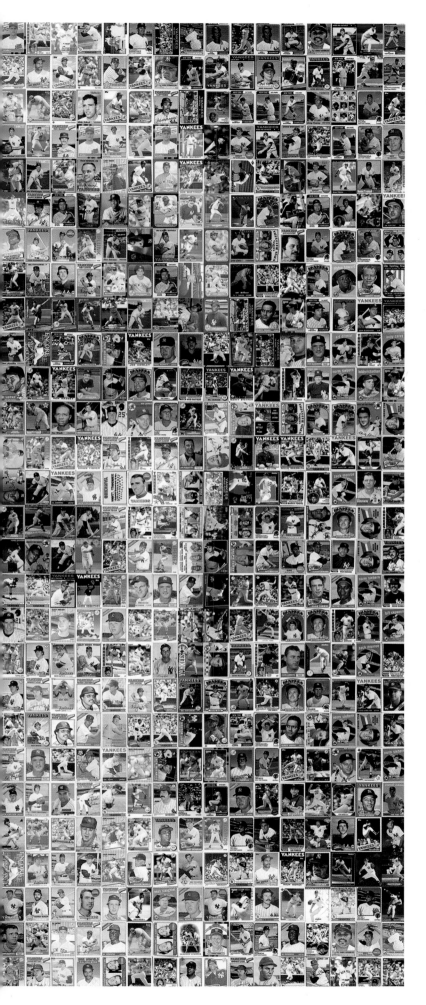

Babe Ruth

George Herman "Babe" Ruth is a seminal figure in American professional sports. A star pitcher for the Boston Red Sox before switching to the Yankees outfield, the "Sultan of Swat" was one of the first five inductees into the Baseball Hall of Fame. Ruth's career records at the time of his retirement included home runs, runs batted in, extra-base hits, slugging percentage, on-base percentage, and walks. In 1999, he was repeatedly voted one of the top athletes of the twentieth century and readers of *USA Today* voted him the "Greatest Athlete of All Time."

Commissioned for Manhattan's ESPN Zone, this Photomosaic portrait of Babe Ruth is composed entirely of New York Yankee baseball cards. It is based on a portrait of the "Bambino" taken in 1927 by distinguished baseball photographer Charles M. Conlon. The original Photomosaic is made from actual cards and measures eight feet high by ten feet wide. Look for such Yankee greats as Lou Gehrig, Phil Rizzuto, Yogi Berra, Billy Martin, Mickey Mantle, Whitey Ford, Elston Howard, Casey Stengel, Roger Maris, Mel Stottlemyre, Reggie Jackson, Catfish Hunter, Graig Nettles, Ron Guidry, Goose Gossage, Willie Randolph, Don Mattingly, Dave Winfield, Rickey Henderson, Paul O'Neill, Bernie Williams, David Cone, Roger Clemens, Orlando "El Duque" Hernandez, and Derek Jeter, as well as Ruth himself.

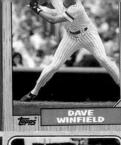

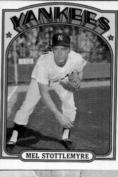

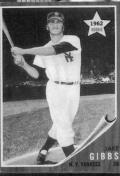
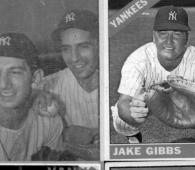
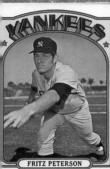

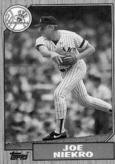

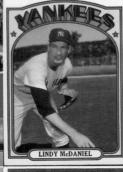

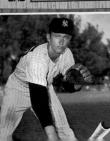

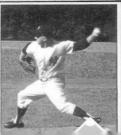

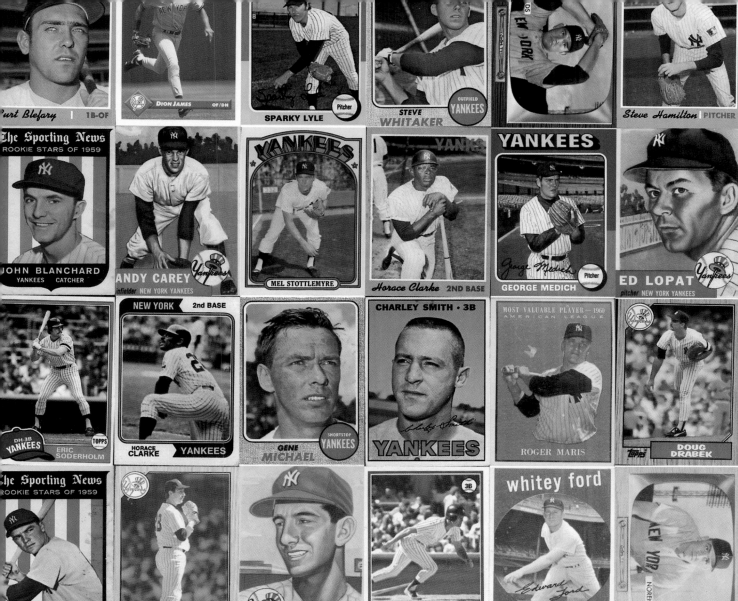

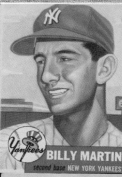
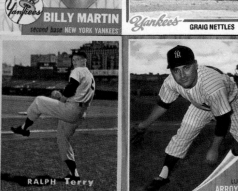
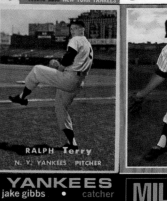
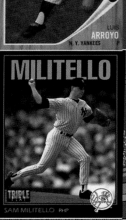

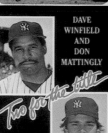

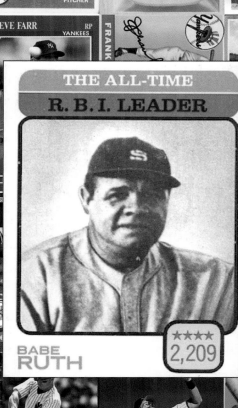
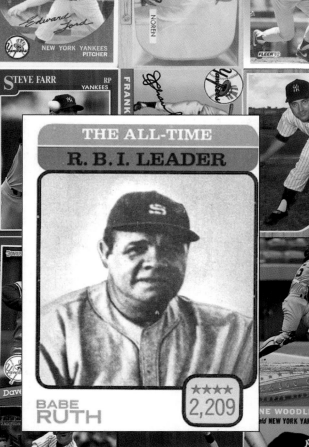
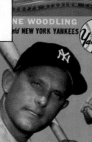

urt Blefary 1B-OF

DION JAMES OF/DH

SPARKY LYLE Pitcher

STEVE WHITAKER Outfield YANKEES

Steve Hamilton PITCHER

ENCORE

The Sporting News ROOKIE STARS OF 1959
JOHN BLANCHARD YANKEES CATCHER

ANDY CAREY Infielder NEW YORK YANKEES

YANKEES
MEL STOTTLEMYRE

YANKS
Horace Clarke 2ND BASE

YANKEES
GEORGE MEDICH Pitcher

ED LOPAT pitcher New York Yankees

AL PULIDO Topps

ERIC SODERHOLM DH-3B YANKEES Topps

NEW YORK 2nd BASE
HORACE CLARKE YANKEES

GENE MICHAEL SHORTSTOP YANKEES

CHARLEY SMITH · 3B YANKEES

MOST VALUABLE PLAYER — 1960 AMERICAN LEAGUE
ROGER MARIS

DOUG DRABEK Topps

FRITZ BRICKELL Shortstop

The Sporting News ROOKIE STARS OF 1959
DERON JOHNSON YANKEES OUTFIELD

ROD SCURRY O-Pee-Chee

BILLY MARTIN second base NEW YORK YANKEES

GRAIG NETTLES 3B Yankees

whitey ford Edward Ford NEW YORK YANKEES PITCHER

NEW YORK NOREN

Fleer

ROLAND SHELDON N.Y. YANKEES P

TOM STURDIVANT NEW YORK YANKEES PITCHER

RALPH TERRY N. Y. YANKEES PITCHER

LUIS ARROYO H. Y. YANKEES P

STEVE FARR RP YANKEES

FRANK

AR

YANKEES
n Woods OUTFIELD

YANKEES frank tepedino · outfield

YANKEES jake gibbs · catcher

MILITELLO SAM MILITELLO PHP TRIPLE Donruss

COLEMAN

NE WOODLING New York Yankees

THE ALL-TIME
R.B.I. LEADER
★★★★ 2,209
BABE RUTH

DAVE WINFIELD AND DON MATTINGLY Two for the title

Migrant Mother

BY DOROTHEA LANGE

Migrant Mother, Nipomo, California is one of the most famous photographs of the twentieth century. Dorothea Lange captured this image in March 1936 for the Farm Security Administration (FSA) while photographing California's impoverished migrant farm camps.

The FSA photography project documented rural life throughout America during the Great Depression. Project director Roy Stryker transformed what could have been an ordinary government photography project into a landmark in modern photojournalism by hiring exceptional photojournalists and giving them wide latitude in their assignments. Besides Lange, participating photographers included Walker Evans, Gordon Parks, Arthur Rothstein, and Ben Shahn. Robert Silvers used their FSA images to create what has become one of his most popular Photomosaics.

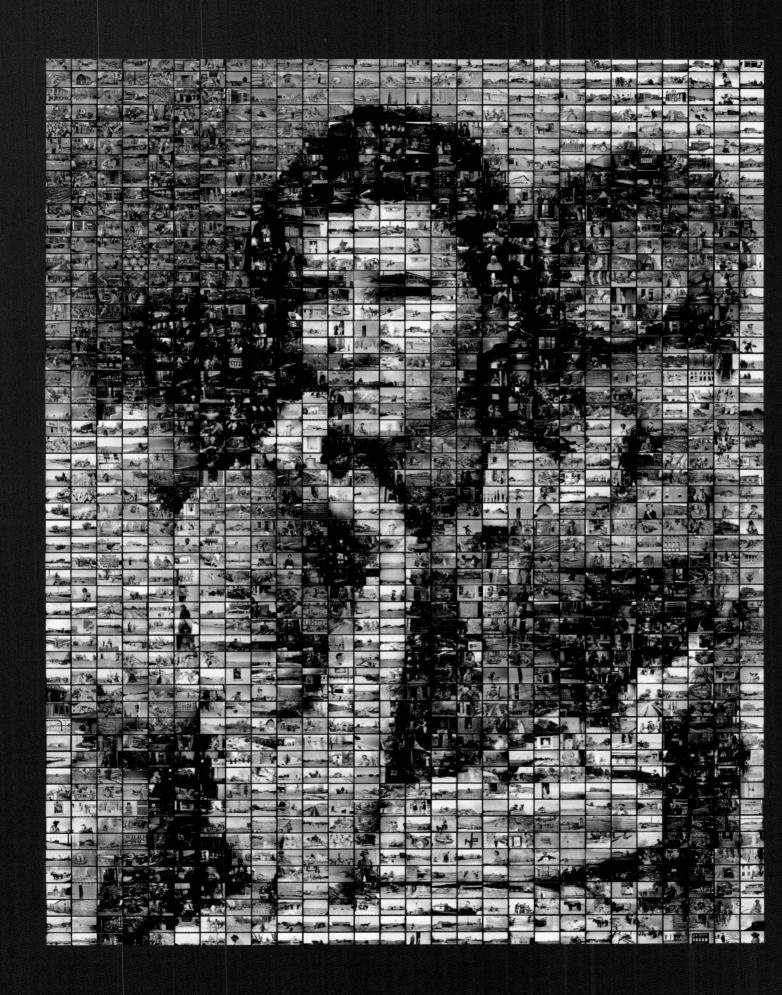

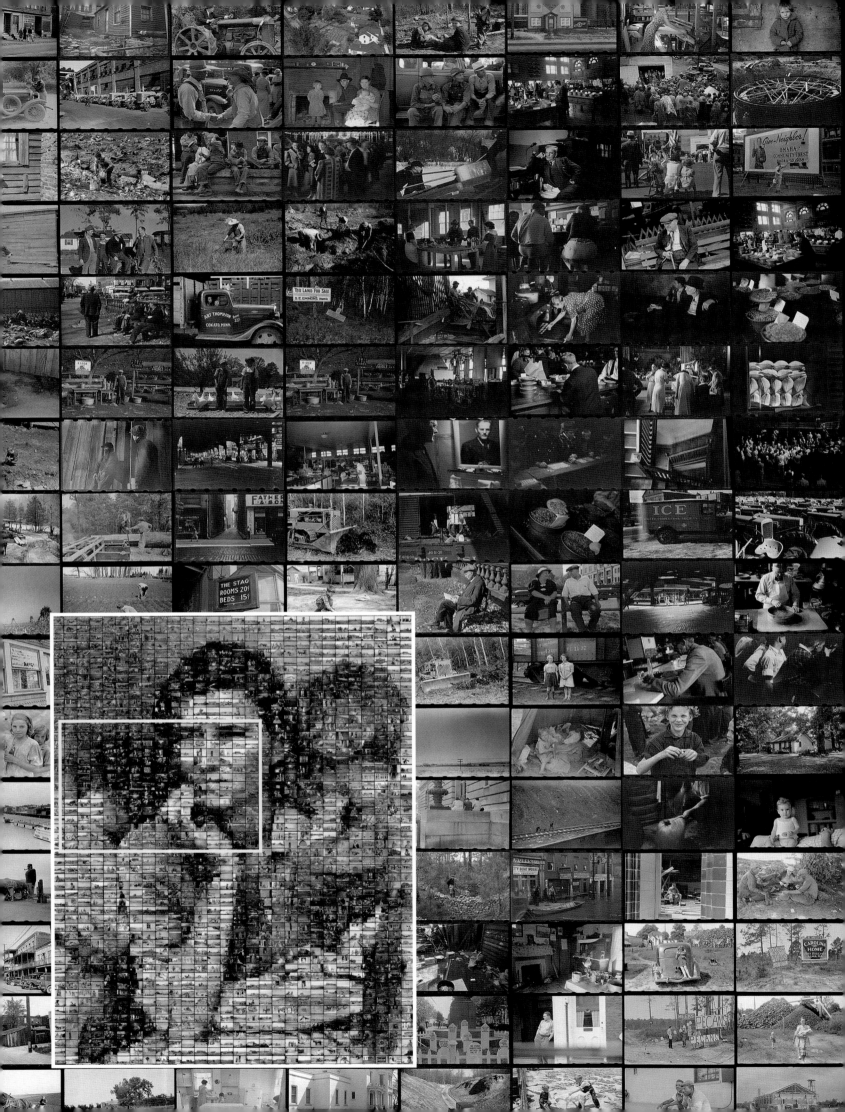

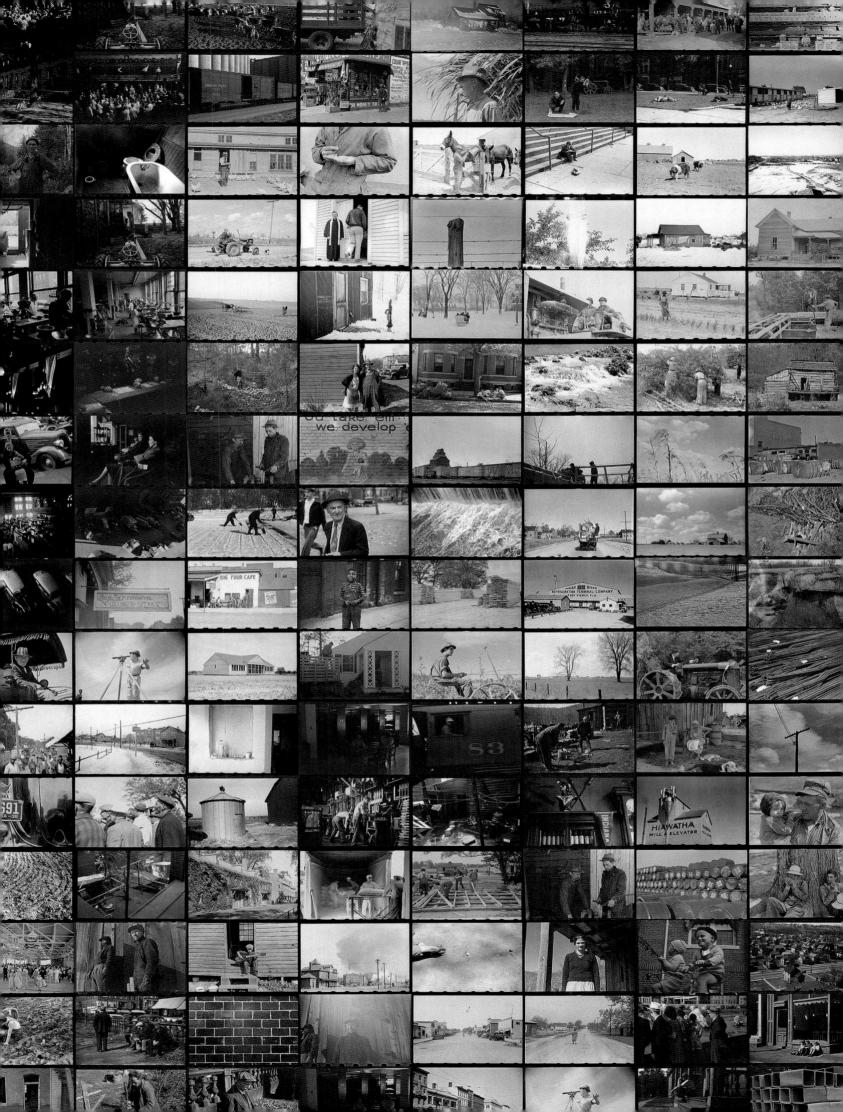

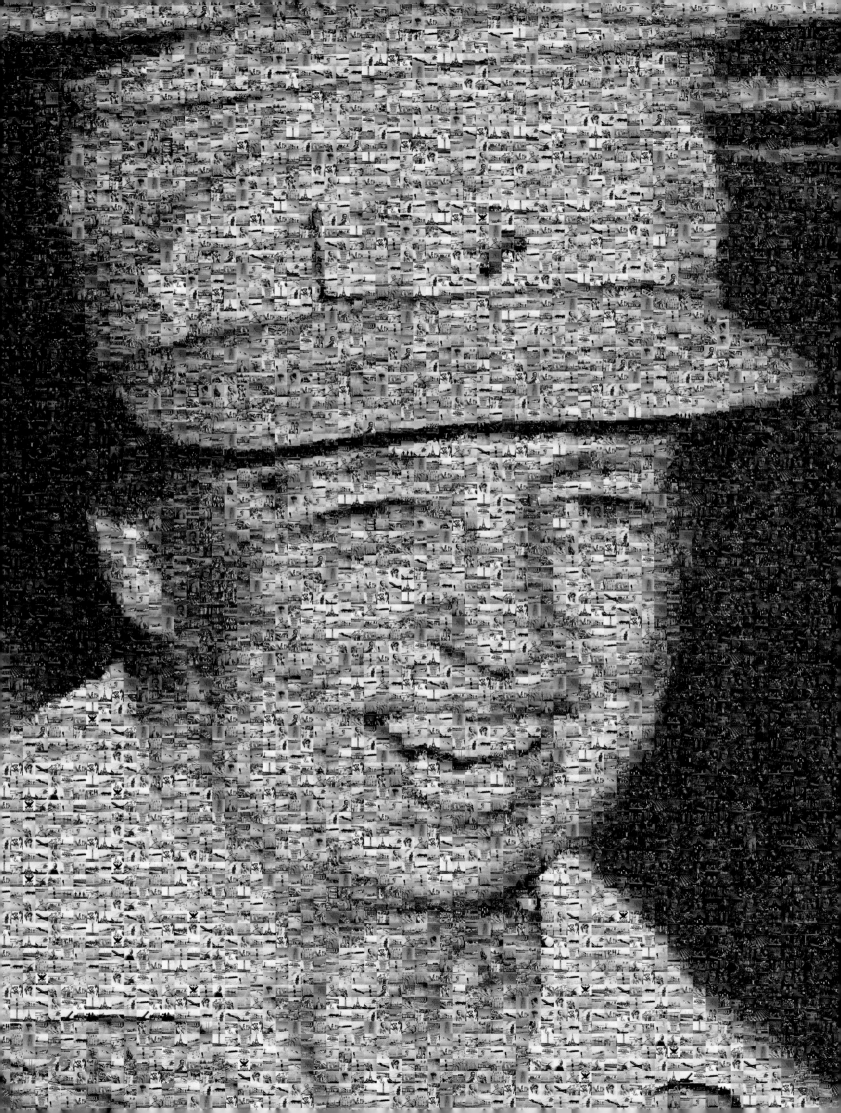

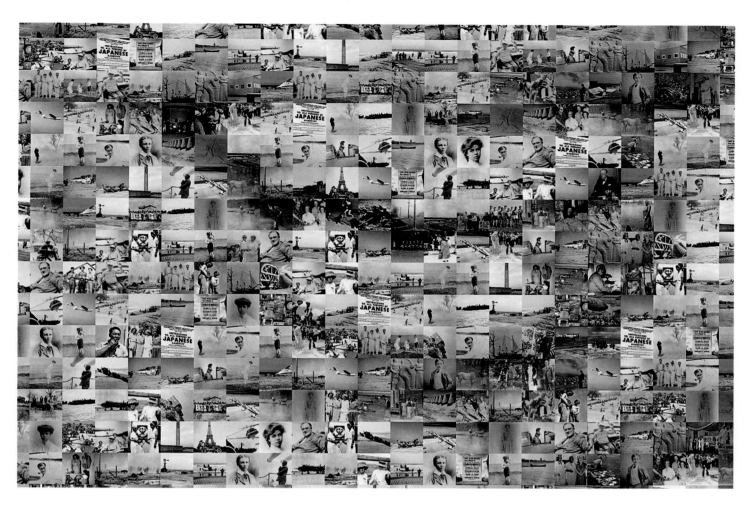

Eleanor Roosevelt

Throughout her life, Eleanor Roosevelt worked tirelessly as an advocate for civil rights, the women's movement, and occupational safety. During her twelve years in the White House, she transformed the role of First Lady by publicly adopting social reform as her personal cause. Later, as head of the United Nations Human Rights Commission, she spearheaded passage of the landmark Universal Declaration of Human Rights. Silvers's Photomosaic portrait of Eleanor Roosevelt is composed of archival photos depicting her life and accomplishments augmented by photos of American life during the New Deal and World War II eras.

27

Marilyn Monroe

A budding starlet for many years, Marilyn Monroe (née Norma Jean Mortenson) finally achieved true stardom in 1953 with the films *Gentlemen Prefer Blondes* and *How to Marry a Millionaire*. In January 1954, her marriage to Yankee great Joe DiMaggio solidified her emerging icon status. Later that year, Hugh Hefner tapped Marilyn as his first *Playboy* cover girl and centerfold—a choice that helped put Hef's monthly lifestyle journal on the cultural map.

In 1999, *Playboy* asked Robert Silvers to re-create the centerfold of that first issue as a Photomosaic made from all 540 subsequent *Playboy* covers, in addition to the very first. Silvers's mosaic, which ran as the cover for *Playboy*'s forty-fifth-anniversary issue, was unveiled at a gala event in New York.

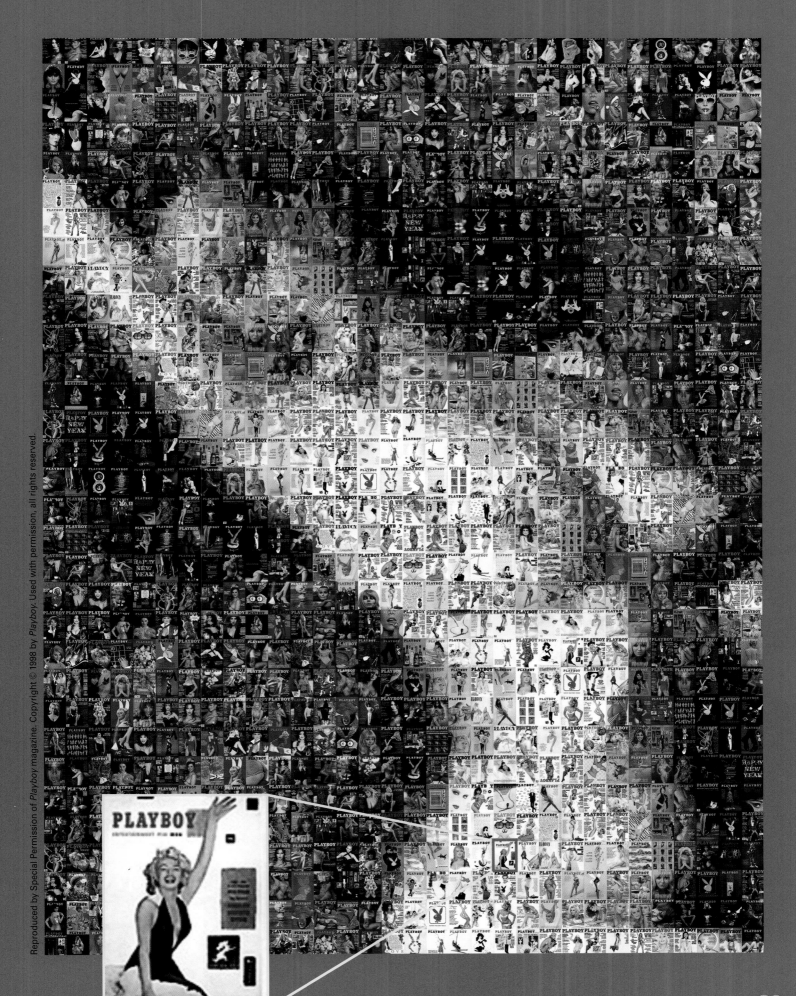

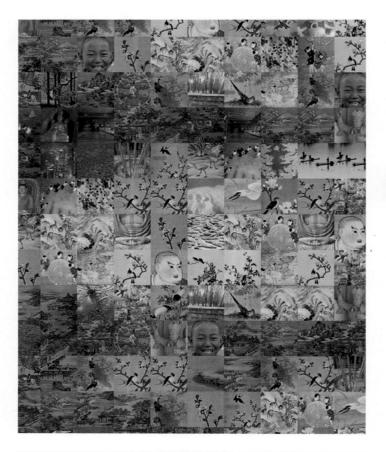

Mao Zedong

China's course during the twentieth century can be largely attributed to one man: Mao Zedong. Mao established the People's Republic of China after the 1949 civil war and served as its president until his death in 1971.

In 2000, the Intergovernmental Philatelic Corporation, a private New York company that produces postage stamps for seventy-five countries around the world, commissioned this Photomosaic, which Robert Silvers created from delicate brush paintings, monumental Buddhist sculpture, historical photos, and scenes photographed throughout contemporary China. It is part of a Photomosaic stamp series that includes such twentieth-century luminaries as Albert Einstein, Princess Diana, Abraham Lincoln, and Britain's Queen Mother.

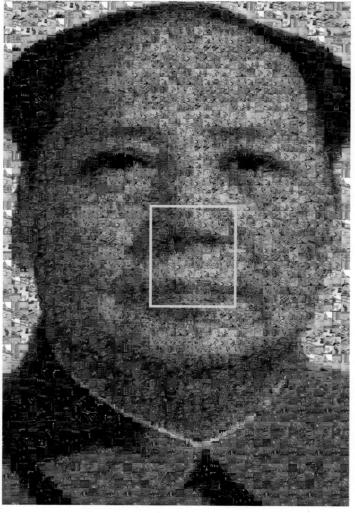

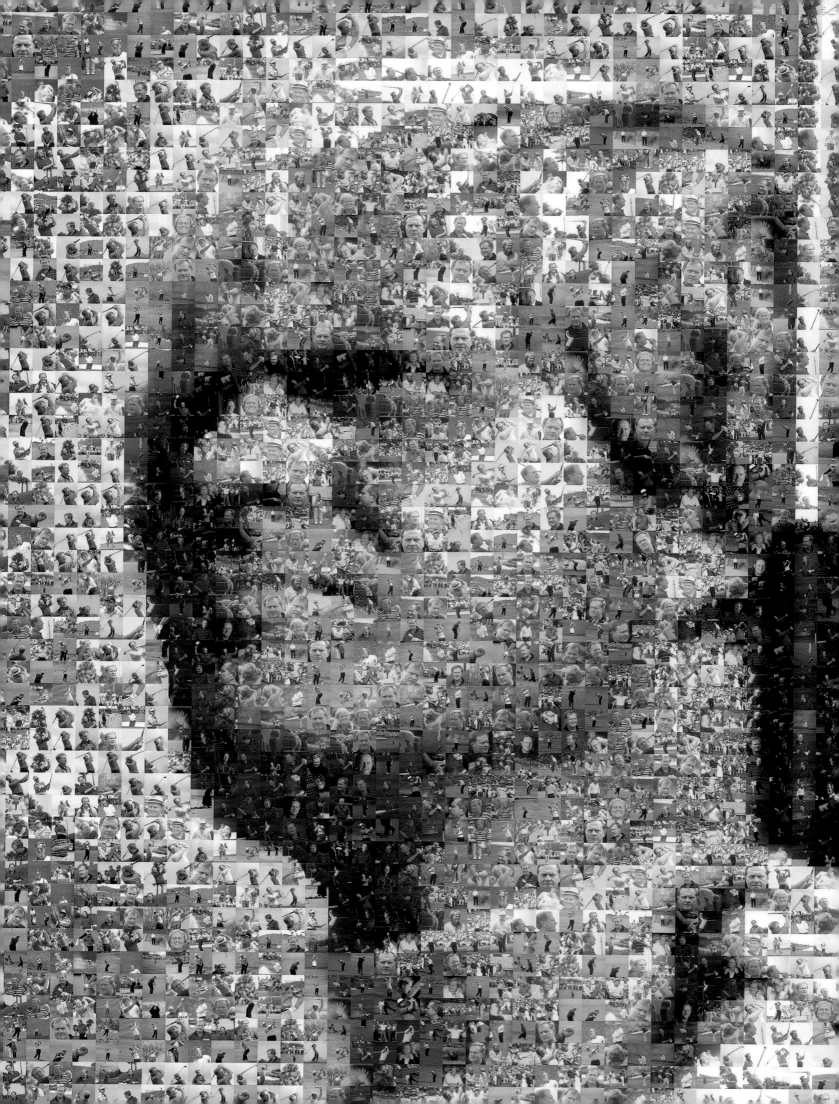

Jack Nicklaus

PROFESSIONAL GOLFER

One of the greatest golfers of all time, Jack Nicklaus made his professional debut at the Los Angeles Open in January 1962. Only five months later he won the prestigious U.S. Open in a dramatic showdown with fellow legend Arnold Palmer. No one was surprised when he was named 1962 PGA Rookie of the Year. The "Golden Bear" has smashed the career-earnings mark time and again. He was the first player to win $3 million (1977), $4 million (1983), and $5 million (1988). He has been named Golfer of the Century twice—by *Golf* magazine and *Golf Monthly* (UK). Nicklaus Golf commissioned this Photomosaic portrait that includes hundreds of shots of Nicklaus doing what he does best.

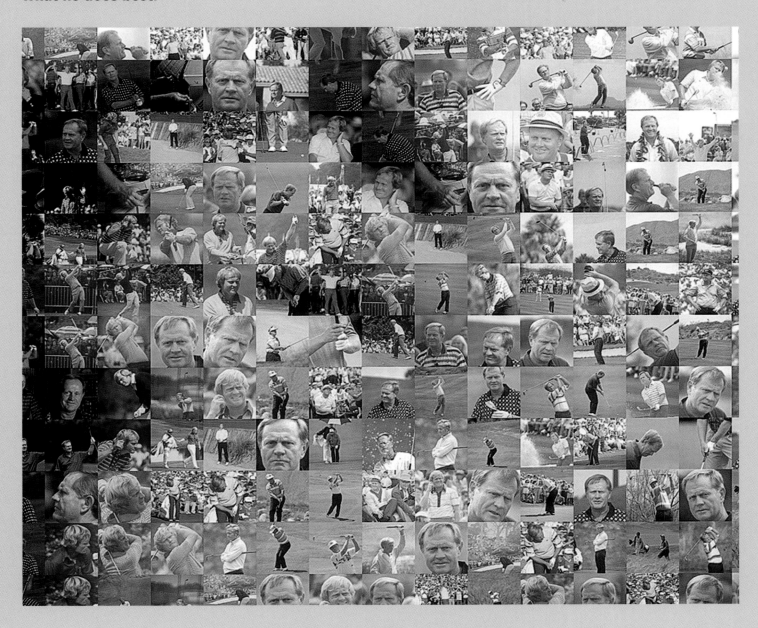

Ahmet M. Ertegun
MUSIC PRODUCER

As a youngster, Ahmet Ertegun, the son of a Turkish diplomat, amassed an impressive jazz and blues collection—partly by going door-to-door asking people if they had old records to sell. In 1948, he cofounded Atlantic Records, one of the first independent labels to challenge music powerhouses RCA, Columbia, and Decca.

By discovering and developing new talent, Atlantic became one of the nation's premier rhythm-and-blues labels, home to Ray Charles, Otis Redding, Wilson Pickett, and Aretha Franklin. Only Berry Gordy's Motown could compete with Atlantic's stable of soul artists.

In the fifties, Atlantic developed an extensive jazz catalogue featuring legends such as John Coltrane, Charles Mingus, Ornette Coleman, and the Modern Jazz Quartet. Ertegun also understood the significance of sixties rock early in the game, signing pioneer groups such as Cream, Buffalo Springfield, Blind Faith, and Led Zeppelin. Ertegun was inducted into the Rock and Roll Hall of Fame in 1987, one of the few nonperformers so honored.

In 1998, Atlantic Records celebrated its fiftieth anniversary and Ertegun's seventy-fifth birthday with a gala event. During the ceremony, Ertegun was presented with a version of this Photomosaic created from the many Atlantic record covers produced during his reign.

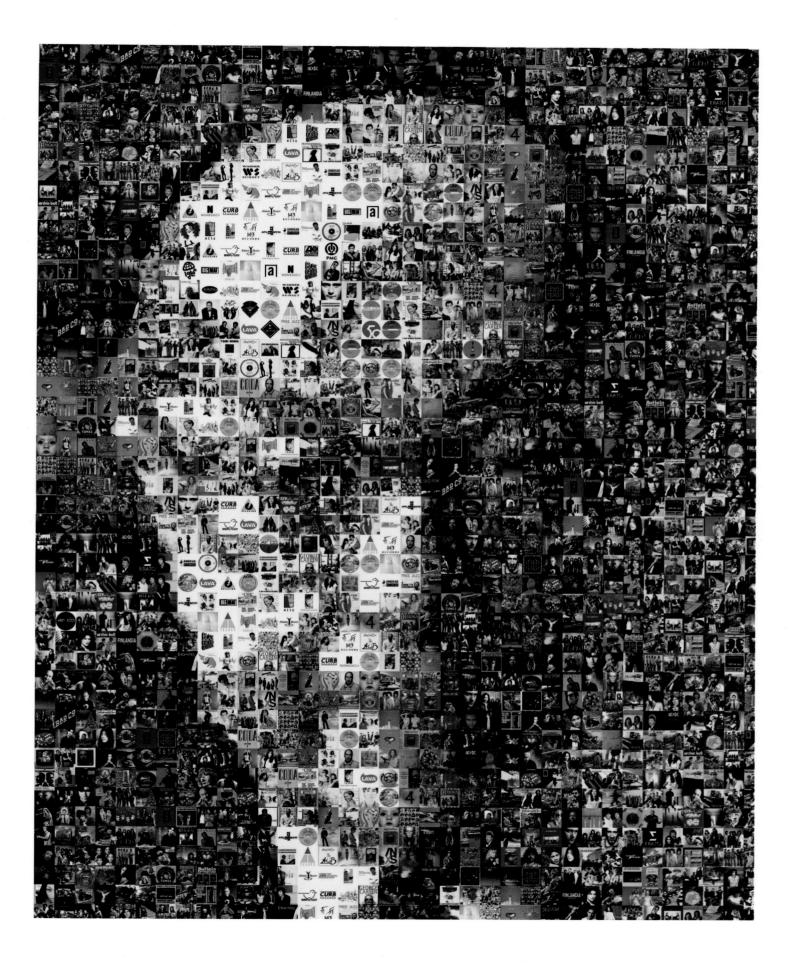

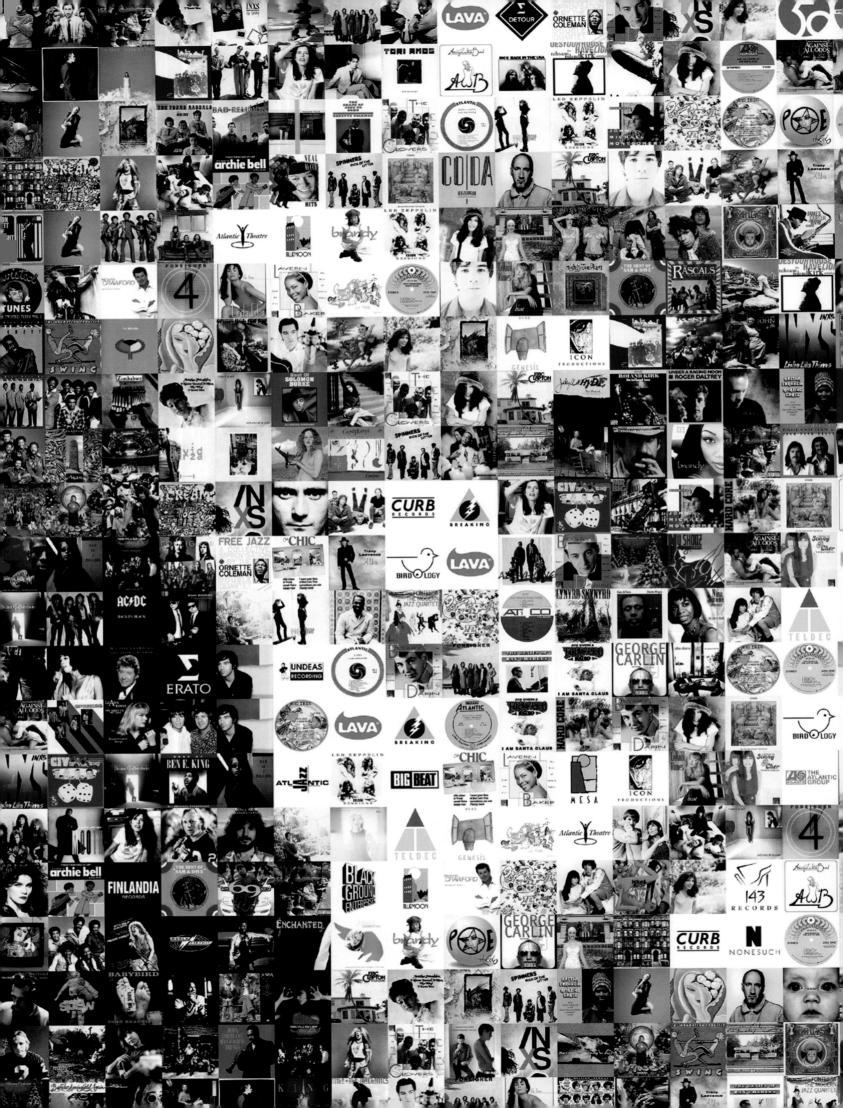

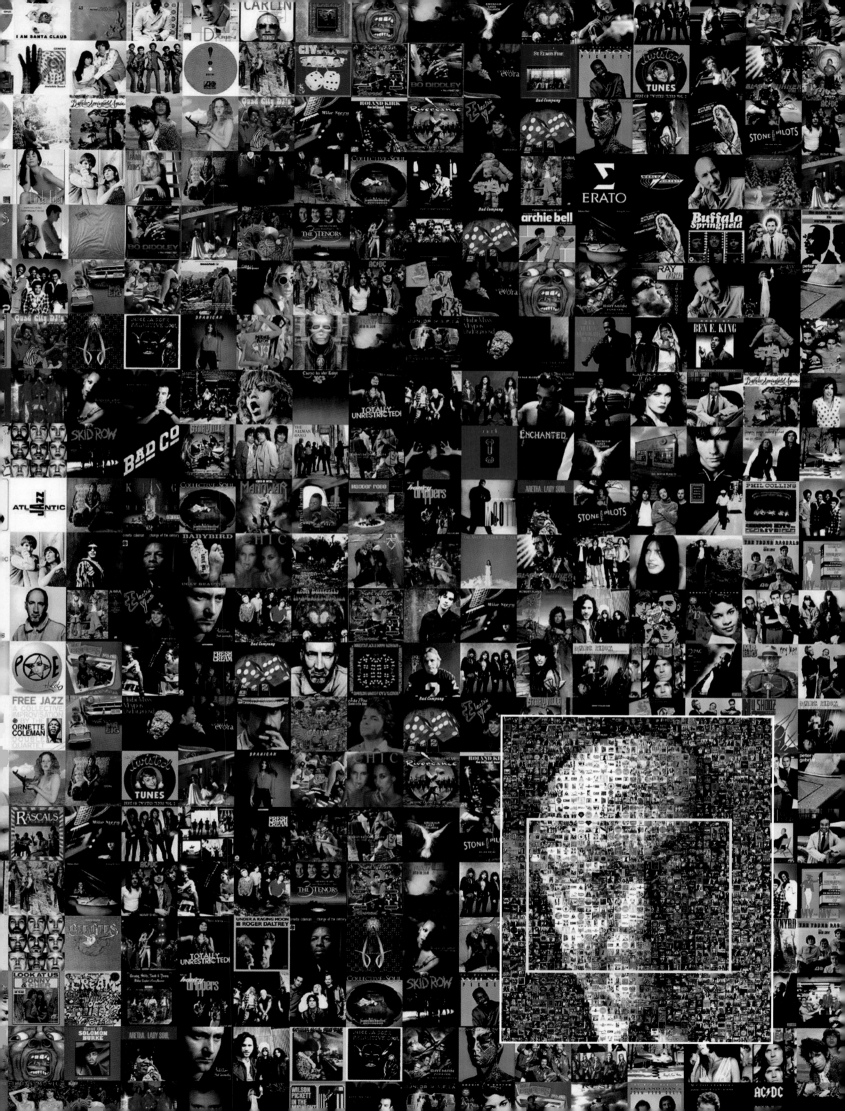

Richard M. Nixon

UNITED STATES PRESIDENT

Richard Nixon's tenure in the White House was marked by paranoia particularly during the 1973–1974 Watergate affair and Nixon's resignation. During the congressional Watergate hearings, Nixon's famous "enemies list," a compendium of more than two hundred individuals and organizations, came to light. In 1999, *Esquire* magazine commissioned Robert Silvers to create a portrait of Nixon made from his enemies real and imagined for its annual Dubious Achievement issue.

The tiles in this Photomosaic include, among others, Muhammed Ali, Woody Allen, Jack Anderson, Birch Bayh, Jerry Brown, Fidel Castro, Bob Dylan, Jane Fonda, Jerry Garcia, Dick Gregory, Barry Goldwater, Howard Hughes, Hubert Humphrey, Martin Luther King, Jr., Edward Kennedy, John F. Kennedy, Robert Kennedy, John Lennon, Shirley MacLaine, Edmund Muskie, Walter Mondale, Paul Newman, Jack Nicholson, William Proxmire, Dan Rather, Nelson Rockefeller, Daniel Schorr, Frank Sinatra, Gloria Steinem, Joanne Woodward, and Andy Warhol. Also included are pictures of Nixon himself, possibly his own worst enemy.

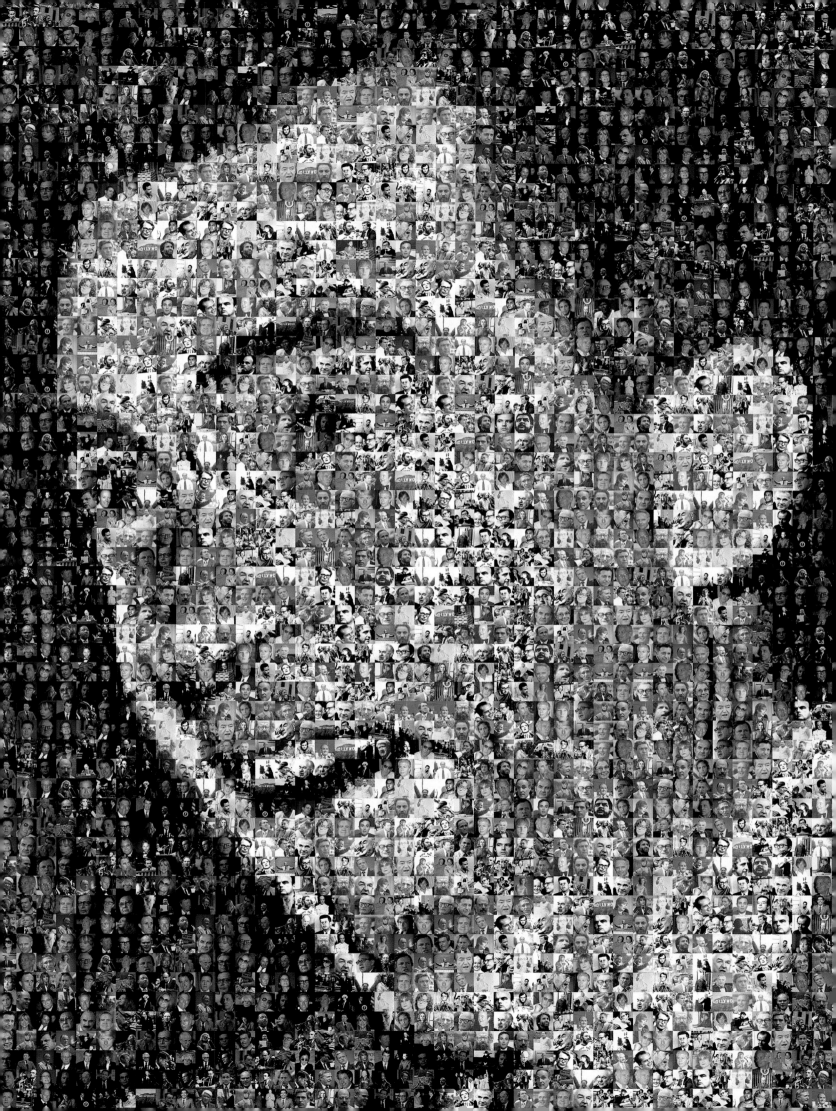

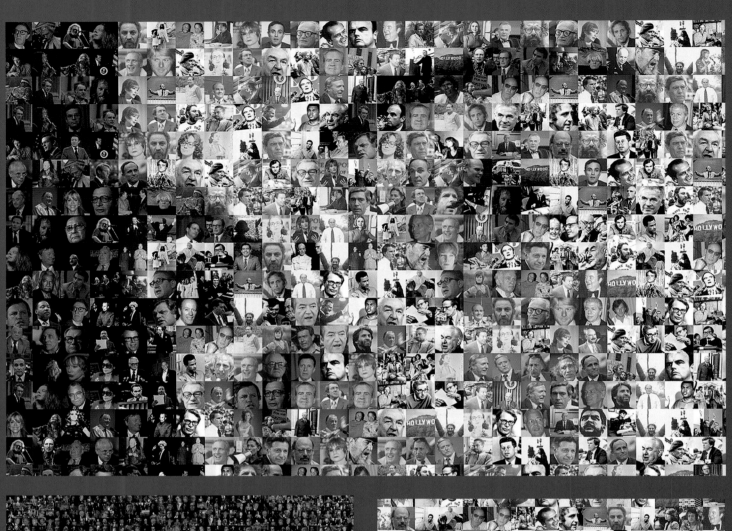
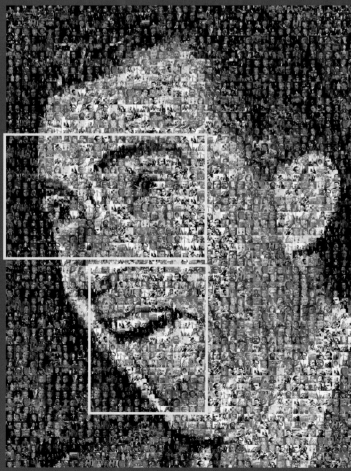
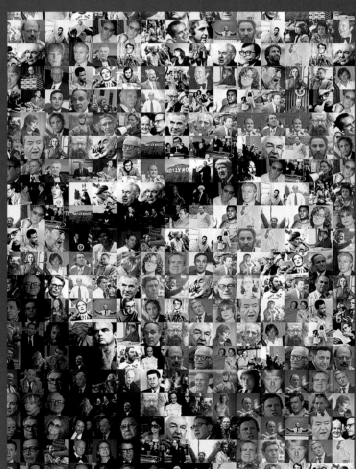

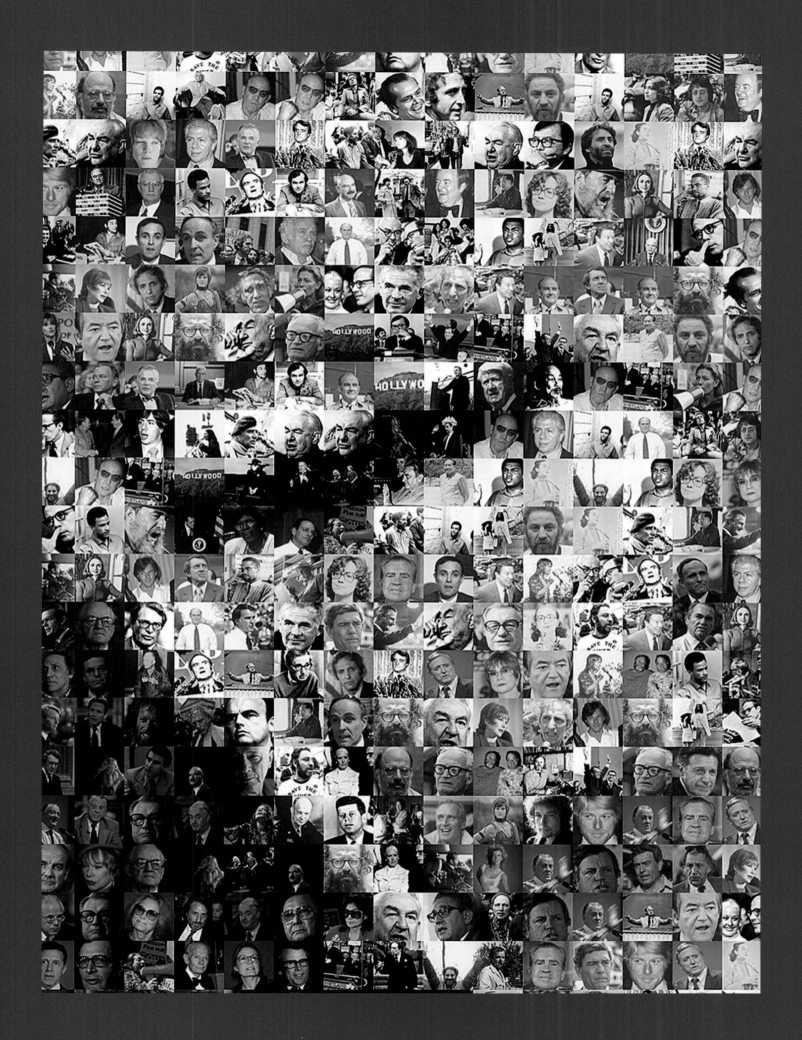

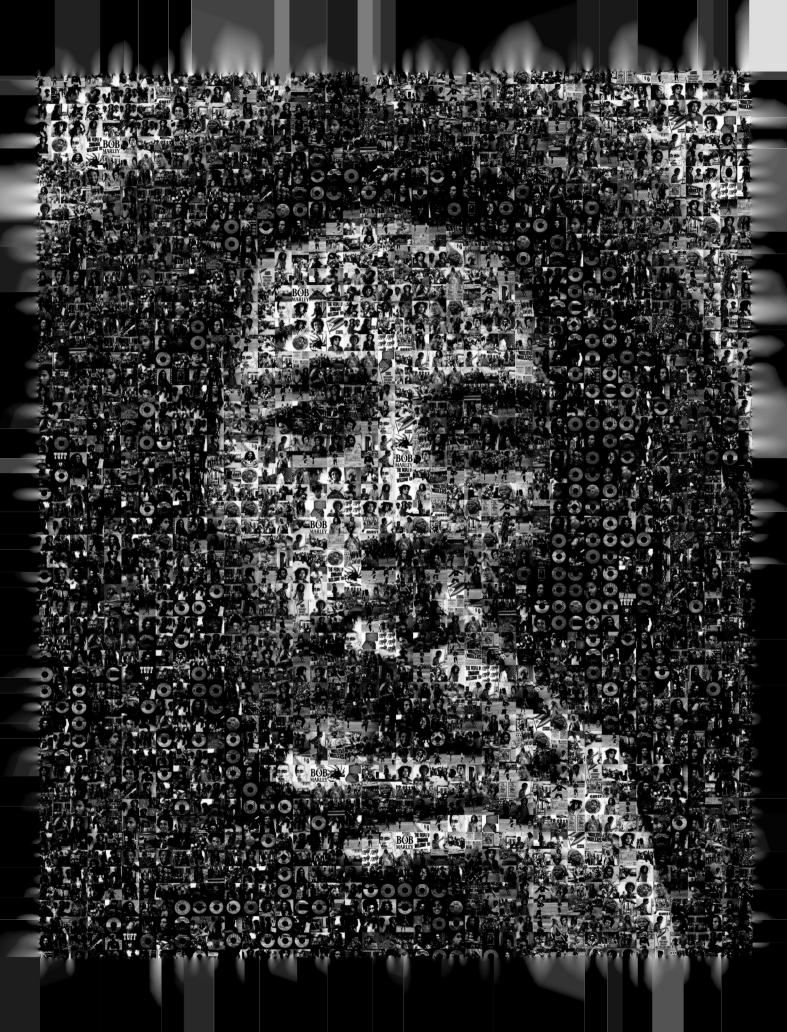

Bob Marley

Bob Marley took reggae from the back streets of Jamaica to the bright lights of the world stage. His mix of socially observant anthems, dreadlock style, and marijuana proselytization made him an internationally acclaimed recording artist and a Jamaican national hero.

Marley made his first recording at the tender age of sixteen. His band, the Wailers, formed and reformed during the early sixties, eventually evolving from ska to a new style known as reggae. In the early seventies, the Wailers cut one of Jamaica's first all-reggae albums and the band began to open for bestselling acts such as Sly and the Family Stone. By middecade, the Wailers were charting hit albums of their own.

In April 1980, at the invitation of President Robert Mugabe, Marley played at Zimbabwe's Independence Day ceremonies. Marley considered this the high point of his life. Shortly thereafter, his health began to deteriorate. Marley had been diagnosed with cancer two years earlier but refused drastic treatment in deference to his Rastafarian beliefs. The disease proved fatal in May 1981.

Robert Silvers's portrait of Bob Marley, originally commissioned by Britain's GB Posters, was created with the approval of the Marley family and Bob Marley Music Ltd., which provided pictures of Marley, his records, his family, and band members for this tribute.

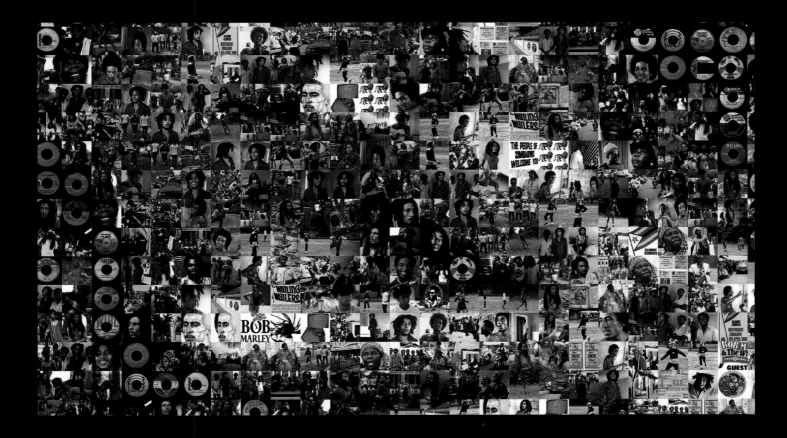

Arnold Schwarzenegger

Ever since Arnold Schwarzenegger burst into the popular consciousness, he has carved out a unique, larger-than-life place for himself as an American icon. By the time the documentary *Pumping Iron* made Schwarzenegger a national celebrity, the Austrian immigrant, had already collected five Mr. Universe titles and six consecutive Mr. Olympia titles. Schwarzenegger, who had grown up in poverty, retired from bodybuilding, earned a degree in business and international economics, and made himself comfortably wealthy through several astute real-estate investments. Schwarzenegger's extraordinary physique also earned him a handful of film roles, but it was the success of 1982's *Conan the Barbarian* that launched Schwarzenegger's meteoric career with leading roles in action films such as *Terminator* (1984) and *Predator* (1987), as well as more lighthearted fare like *Twins* (1988) and *Kindergarten Cop* (1990).

Even after becoming a movie star, Schwarzenegger never forgot his bodybuilding roots. He maintains ties with the bodybuilding community, supports the Special Olympics as International Weight Lifting Coach, and has served as chairman of the President's Council on Physical Fitness. To celebrate Schwarzenegger's contributions to the spirit of bodybuilding *Muscle & Fitness* magazine commissioned this Photomosaic poster for its sixtieth-anniversary issue in 1999. Robert Silvers used past covers of the magazine, male and female bodybuilders, as well as muscular rowers, gymnasts, windsurfers, skiers, and cyclists to create the image of a posing Schwarzenegger during his bodybuilding heyday, circa 1970.

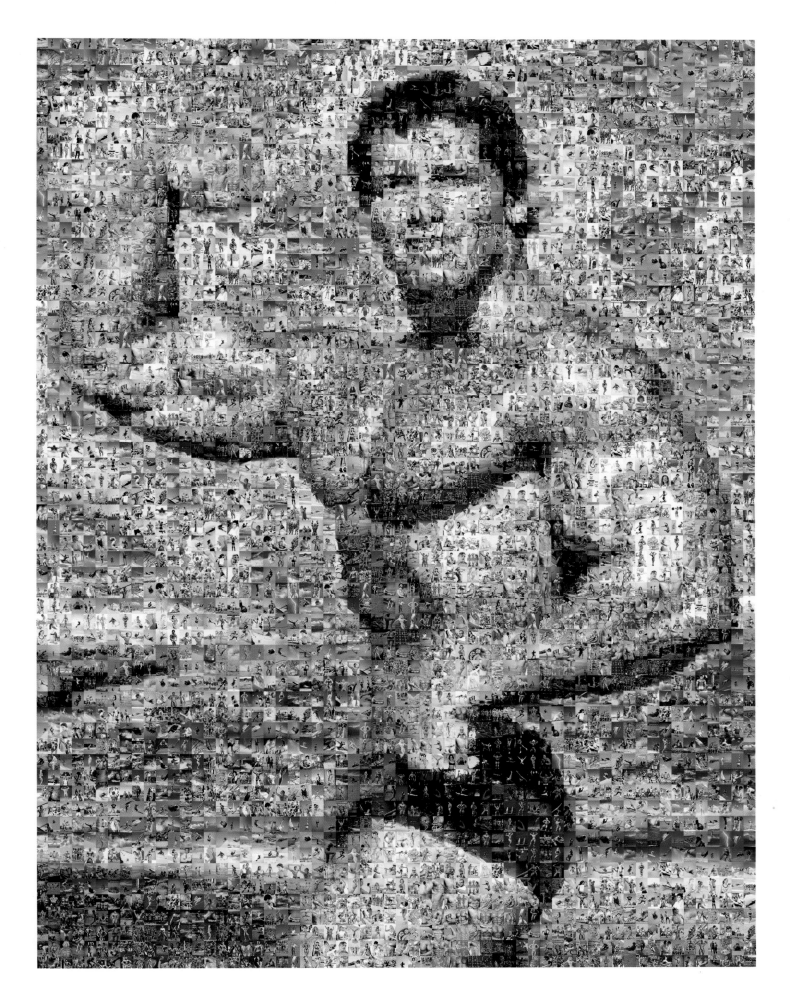

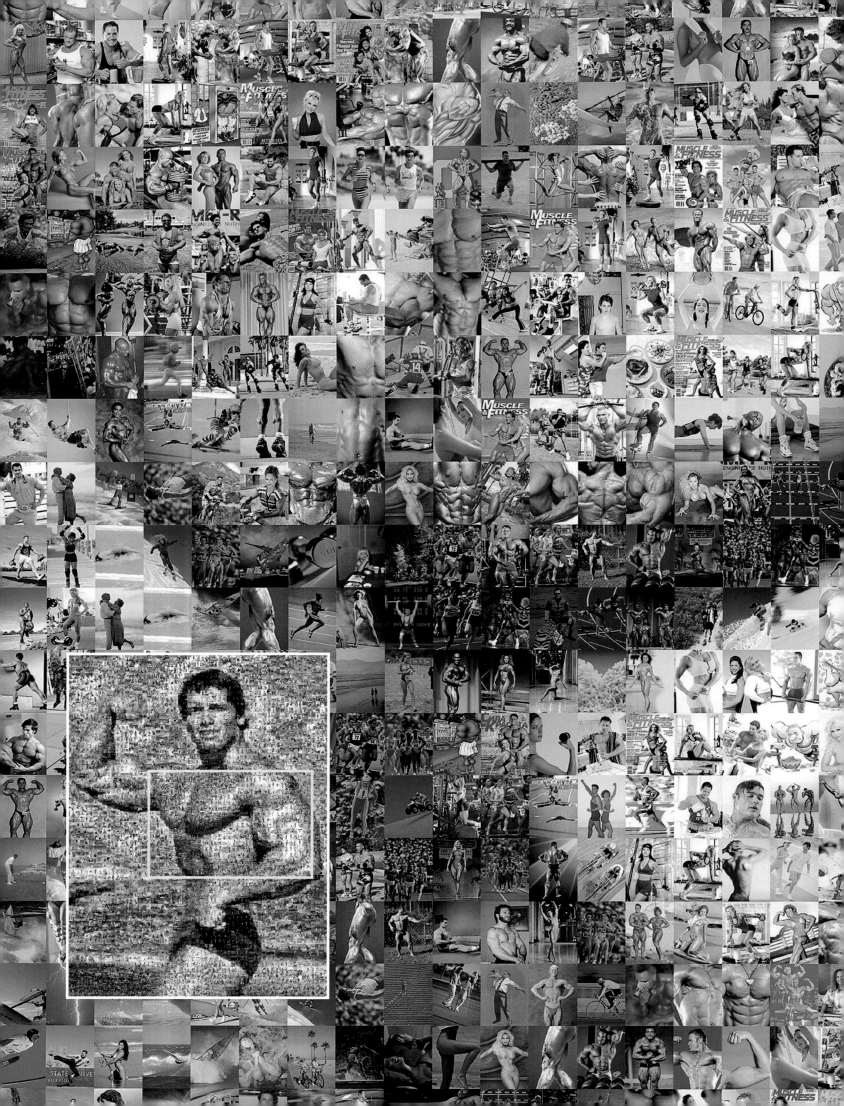

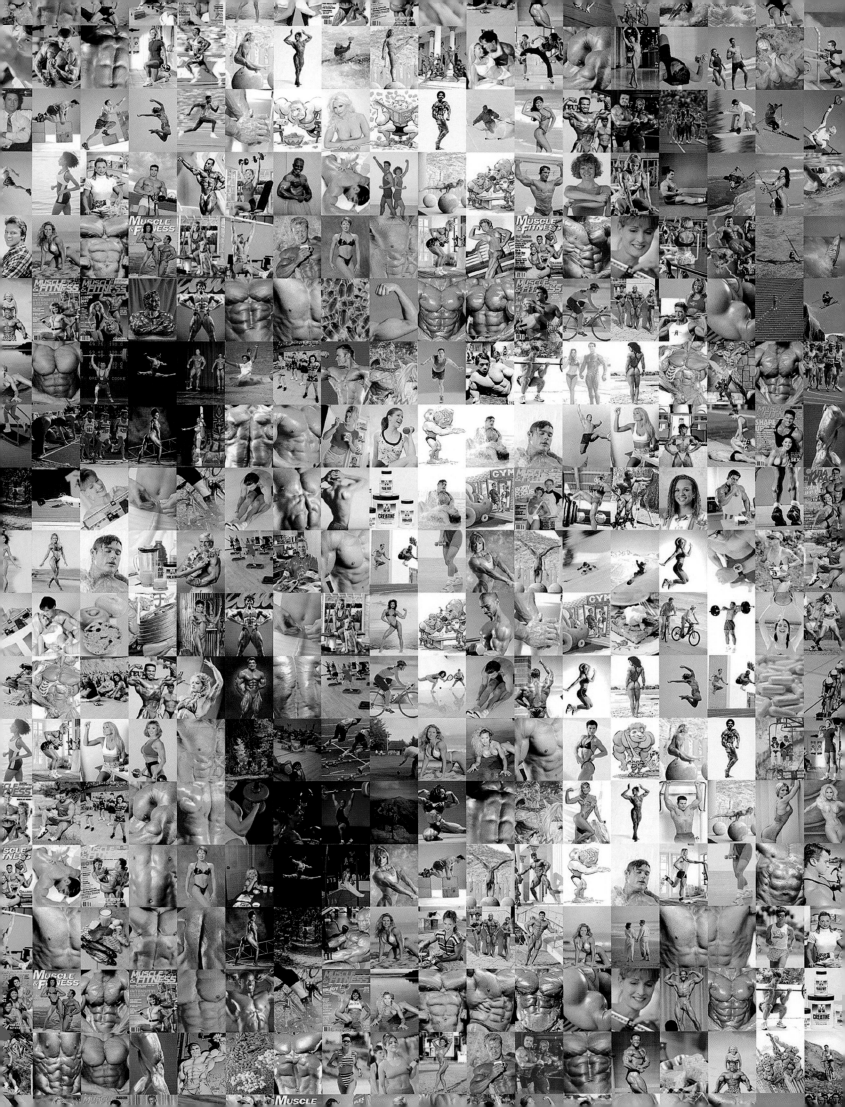

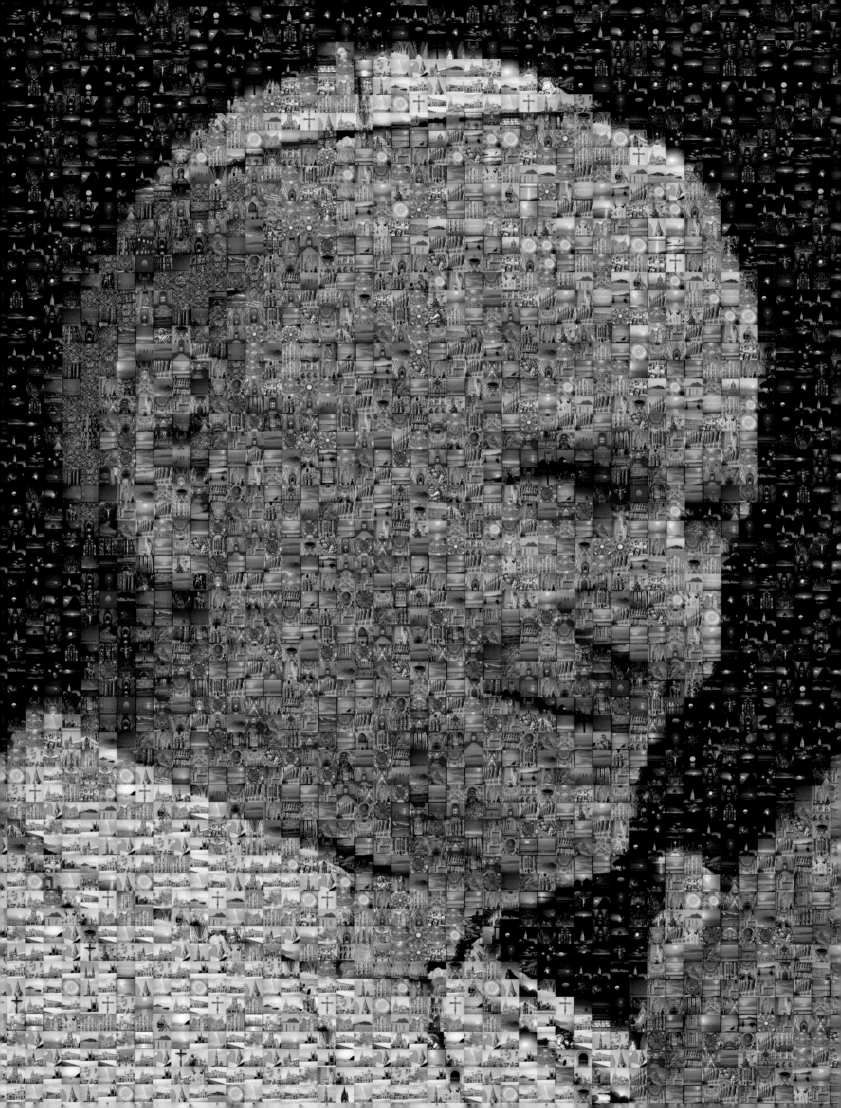

Pope John Paul II

John Paul II, the 264th head of the Roman Catholic Church and spiritual leader of more than one billion Catholics worldwide, was born Karol Wojtyla in Kraków, Poland, in 1920. As a young man, Wojtyla pursued a career in the theater, but during World War II he found his calling and took religious instruction in a clandestine Catholic seminary. Wojtyla was ordained in 1946. Eighteen years later, he was named Archbishop of Kraków, eventually becoming cardinal.

In 1978, the Vatican's College of Cardinals surprised the world (and annoyed Europe's then-Communist Eastern bloc leaders) by selecting Wojtyla as the first non-Italian pope in more than four hundred years. Wojtyla immediately fashioned himself the "Pilgrim Pope," visiting nearly one hundred nations around the globe—on every continent except Antarctica—in the course of his eighty-five international pastoral visits. He is the first pope ever to set foot in many of these countries. Appropriately, this Photomosaic is composed of churches, cathedrals, religious paintings, and stained glass from around the world.

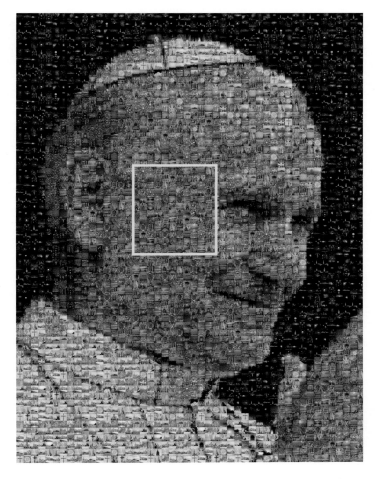

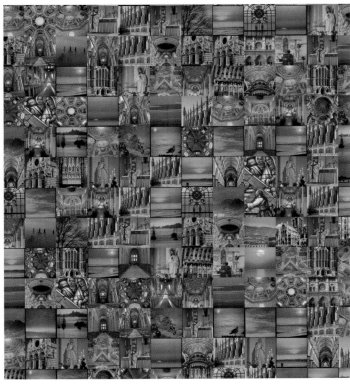

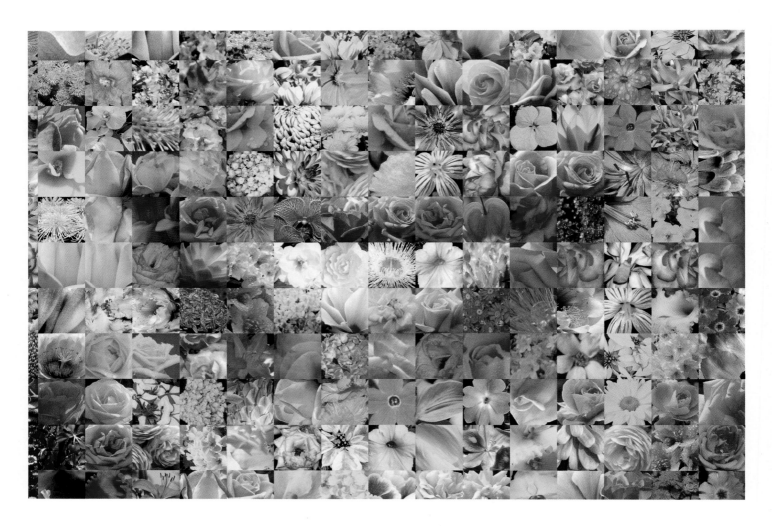

Diana

When Lady Diana Spencer married England's Prince Charles in 1981 their glamorous wedding in St. Paul's Cathedral seemed to be a real-life fairy tale. While the marriage never made it to "happily ever after," Princess Diana channeled her prominence and compassion into charitable work. Best known for her work in the fight against AIDS and the campaign to ban land mines, Princess Diana emerged as a leading humanitarian.

Unfortunately, her beauty and royal station attracted fierce attention from the world's paparazzi. In August 1997, Diana was killed in an automobile accident in Paris while trying to escape photographers. Britons from all walks of life deposited more than a hundred thousand floral bouquets in front of her Kensington Palace home. Therefore, when *Newsweek* commissioned a Photomosaic portrait of the late princess for its 1998 "Pictures of the Year" issue, Robert Silvers decided to build the image from photographs of flowers. This portrait of Diana was also used to create a popular poster of the princess. Suitably, the proceeds from its sale benefited Cambodian land mine victims.

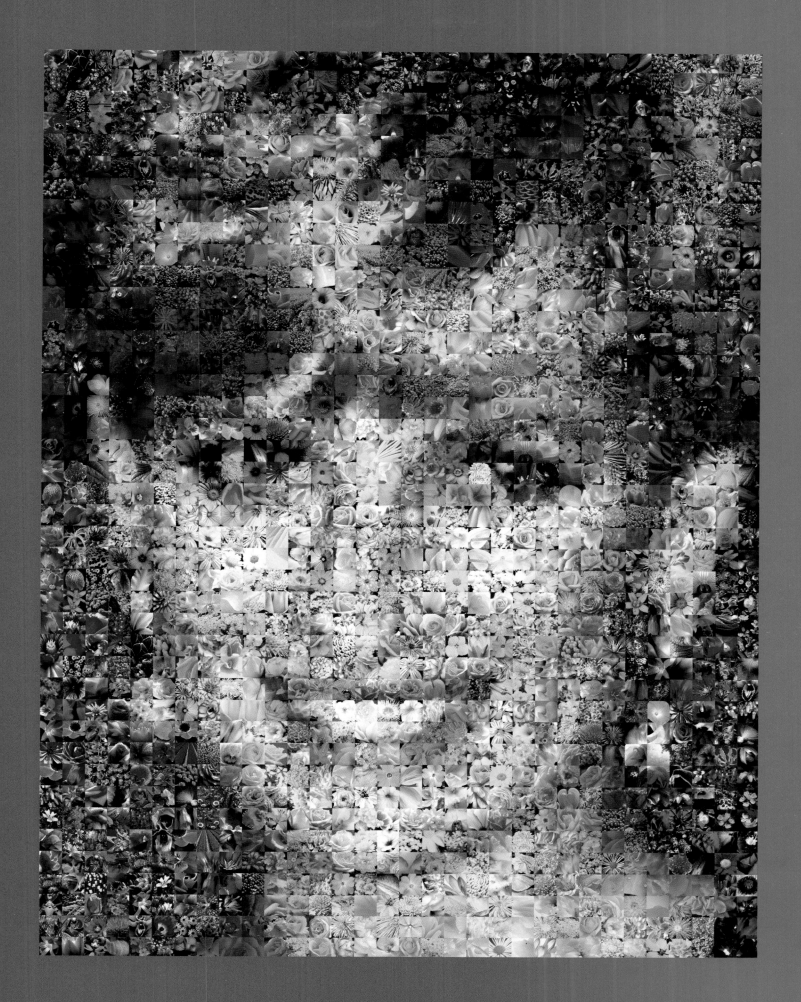

Michael Jordan

ATHLETE

Considered by many to be the greatest basket-ball player ever, Michael Jordan's importance to his sport is comparable only to that of names such as Ruth (baseball), Ali (boxing), Gretzky (hockey), and Pelé (soccer). Drafted from the University of North Carolina in 1984, Jordan led the Chicago Bulls to six NBA championships during his thirteen professional seasons. He was named the NBA's Most Valuable Player six times and was awarded the number-one spot on ESPN's list of the one hundred greatest North American athletes of the twentieth century. Jordan was also selected as *Sports Illustrated*'s Sportsman of the Year three times, more than any other athlete in the magazine's history.

Robert Silvers's Photomosaic of Michael Jordan was commissioned for the tenth-anniversary issue of *Sports Illustrated for Kids*. Silvers used legendary athletes from various professional and Olympic sports as constituent tiles. Look for sports greats Andre Agassi and John McEnroe (tennis), John Elway (football), Wayne Gretzky (hockey), Mia Hamm (soccer), Michelle Kwan (figure skating), Karl Malone (basketball), Mark McGuire (baseball), Kerri Strug (gymnastics), and Tiger Woods (golf) among many others.

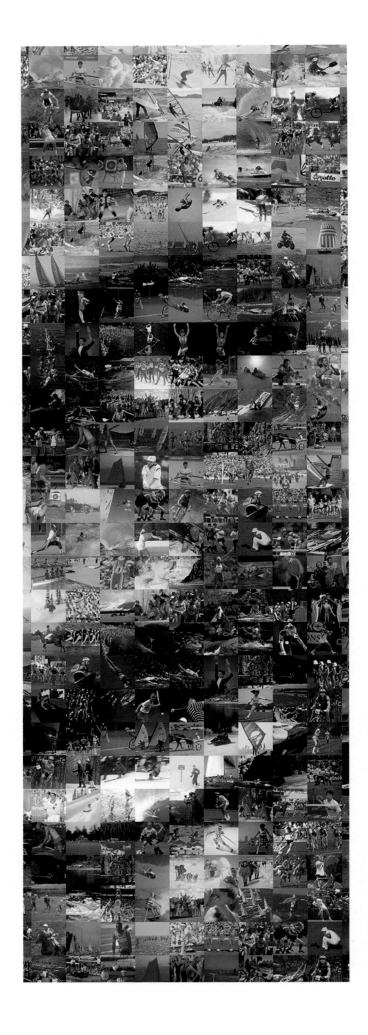

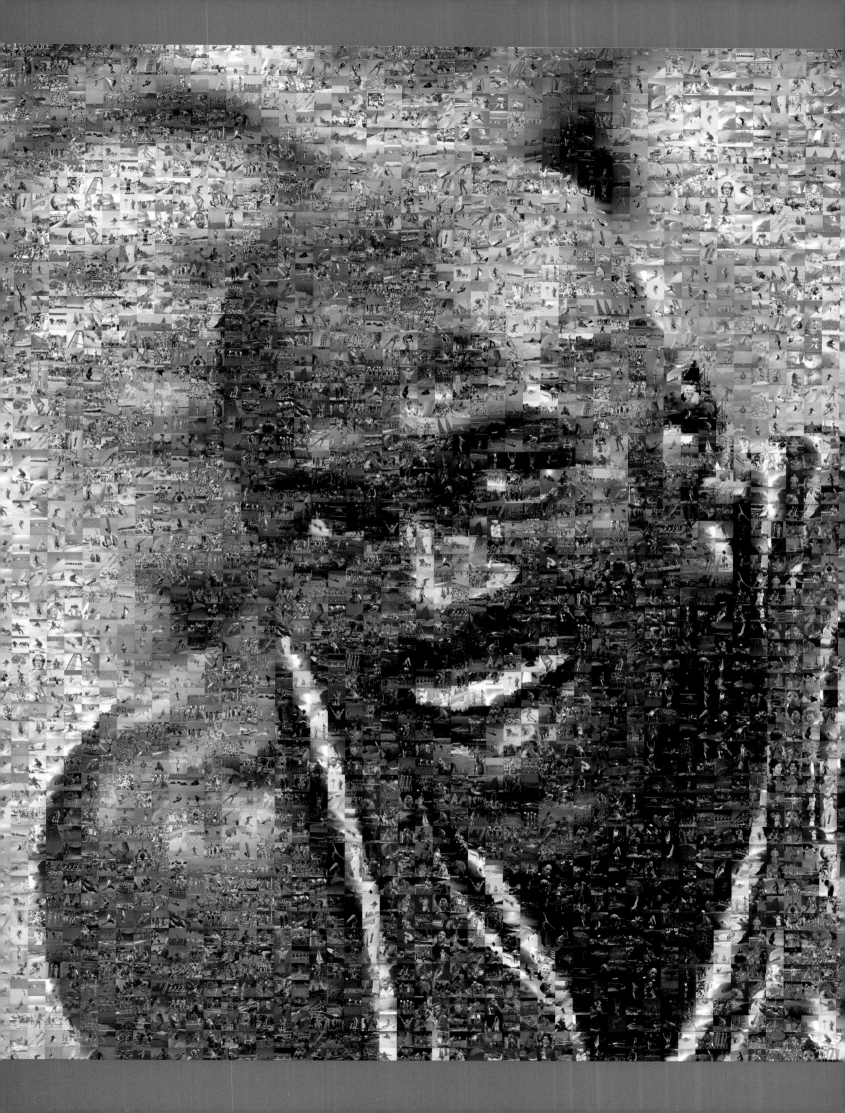

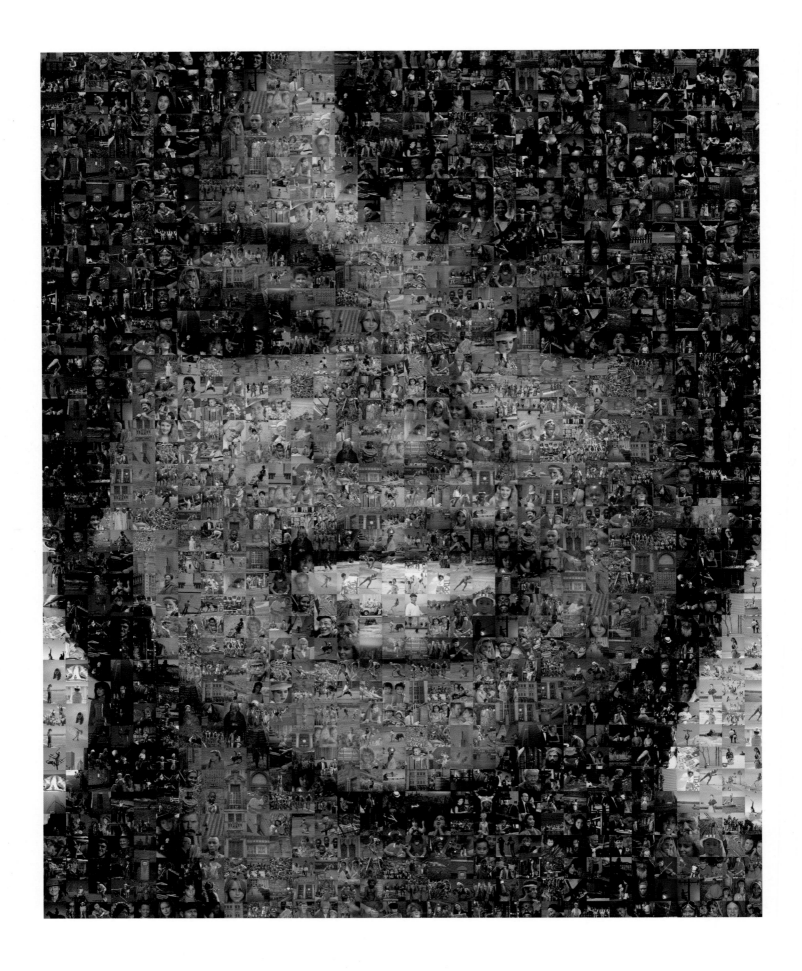

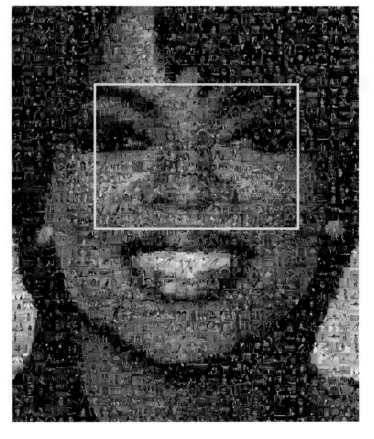

Oprah Winfrey

PERSONALITY AND PERFORMER

Oprah Winfrey has elevated the TV talk show to a new level of influence. In the process, she has become one of America's wealthiest and most influential women. *TV Guide* named Winfrey "Television Performer of the Year" and *Time* magazine anointed her as one of the hundred most influential people of the twentieth century. Oprah can also boast sixteen Emmy awards. Robert Silvers was asked to create this portrait of America's favorite talk-show host when he was featured on her program as an example of a young entrepreneur with a million-dollar idea.

Claudia Schiffer

FASHION MODEL

The last two decades of the twentieth century saw the rise of the "supermodel," a phenomenon wherein the girls modeling fashions and cosmetics became more famous than the houses they represented. Five-feet, eleven-inches tall, blond and blue-eyed, Claudia Schiffer, the face of the Revlon cosmetics empire, was among this select cadre. This Photomosaic of Schiffer, commissioned for the October 1998 issue of *Allure* magazine, uses images of cosmetics, brushes, clips, and scissors to create a portrait of a beautiful woman.

This Photomosaic originally appeared in *Allure.*

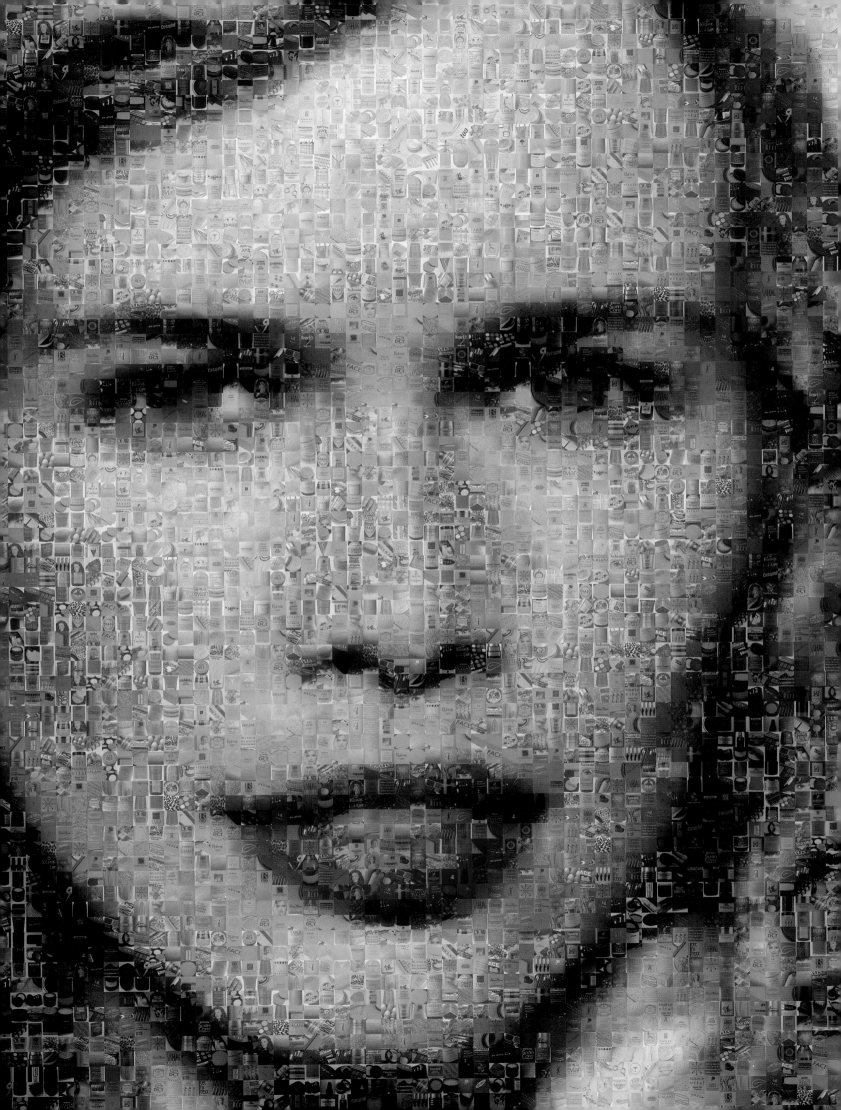

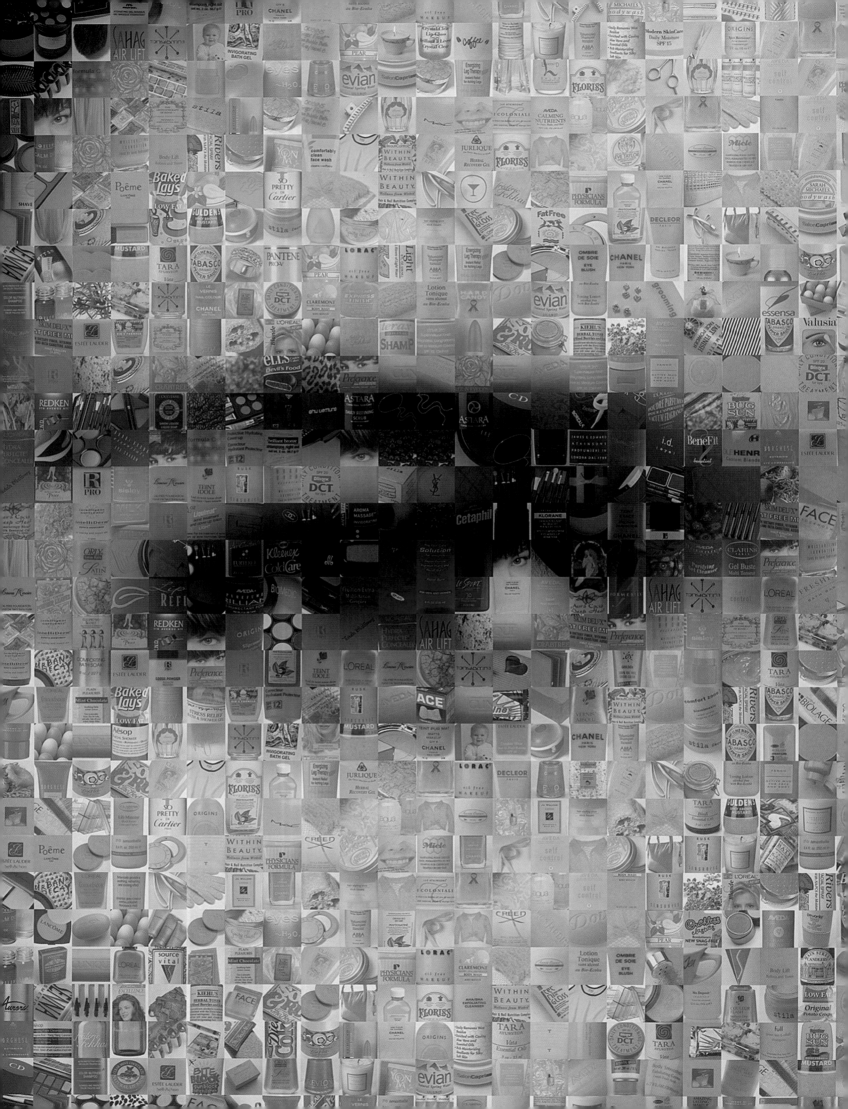

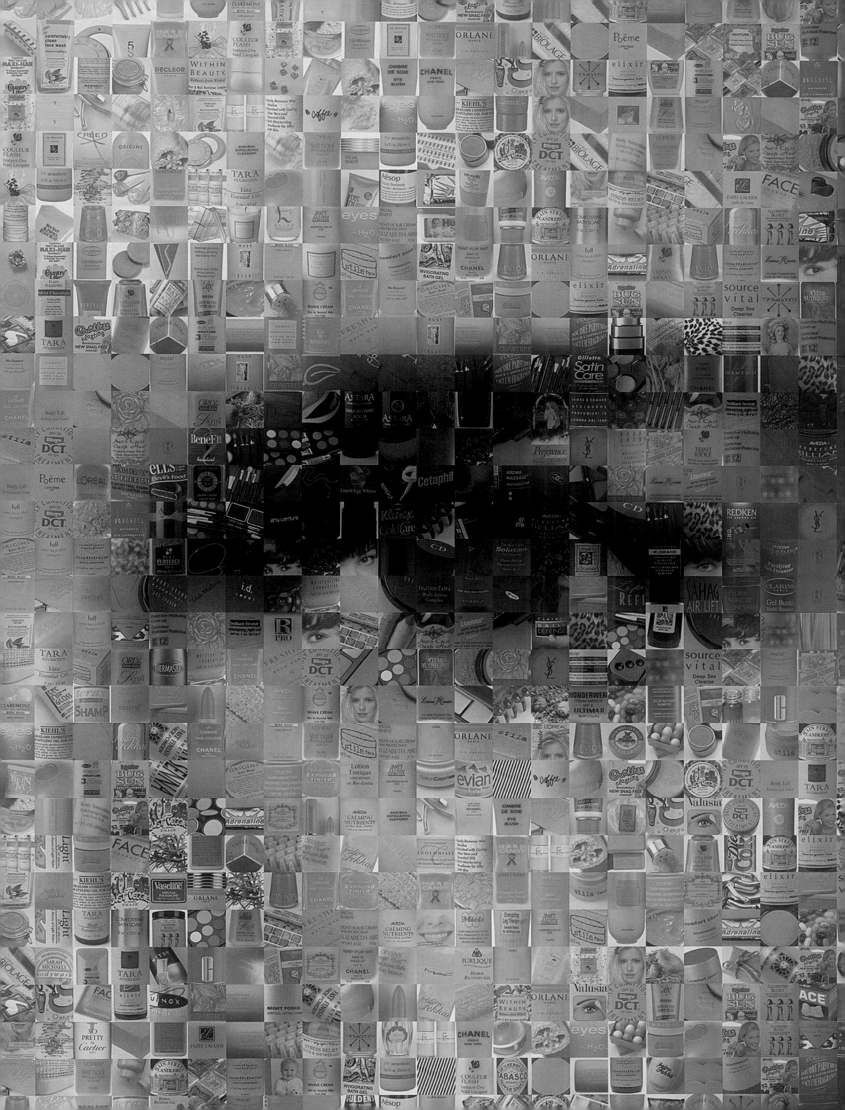

Tim Berners-Lee

Tim Berners-Lee is considered the inventor of the World Wide Web, so his Photomosaic portrait is composed from 2,154 Web pages. Selected fairly randomly, these pages are among an estimated one billion that have been created since the World Wide Web began in 1990.

Berners-Lee is now a professor at MIT's Laboratory for Computer Science and director of the World Wide Web consortium in Cambridge, Massachusetts—a stone's throw from Robert Silvers's own Cambridge studio. So when *Time* magazine asked Silvers to create an image of Berners-Lee for a piece on the twentieth century's leading scientific and technological figures, Silvers took the photograph for the "base" portrait of Berners-Lee himself. Silvers has also taken base portraits for Photomosaics of Bill Gates and Al Gore, among others.

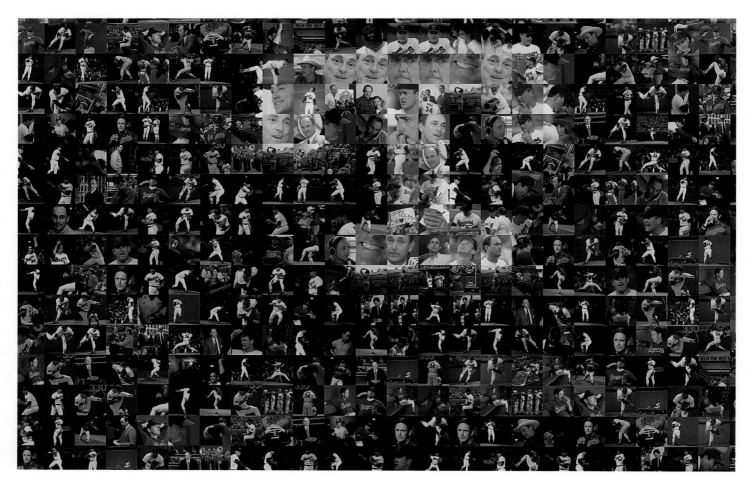

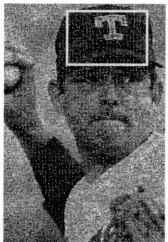

Nolan Ryan

BASEBALL PITCHER

Armed with a fastball dubbed the "Ryan Express," Nolan Ryan was one of the most overpowering pitchers in baseball history. Although he played for losing teams nearly half of his twenty-seven major league seasons, a glance at the record books confirms Ryan's dominance. By the end of his last season in 1993, Ryan's list of pitching records included most strikeouts in a career (5,714) and a single season (383), most career no-hitters (an astonishing 7), and most games with fifteen or more strikeouts (26). These accomplishments made Ryan a fan favorite and a shoo-in for baseball's All-Century Team.

In 1999, Ryan was elected to the Baseball Hall of Fame. To honor that event, the *Fort Worth Star Telegram* published a special Nolan Ryan section and commissioned this Photomosaic for its cover. To create the portrait, Robert Silvers used photographs of baseball diamonds, baseball players, and an Eadweard Muybridge-like sequence of Ryan pitching.

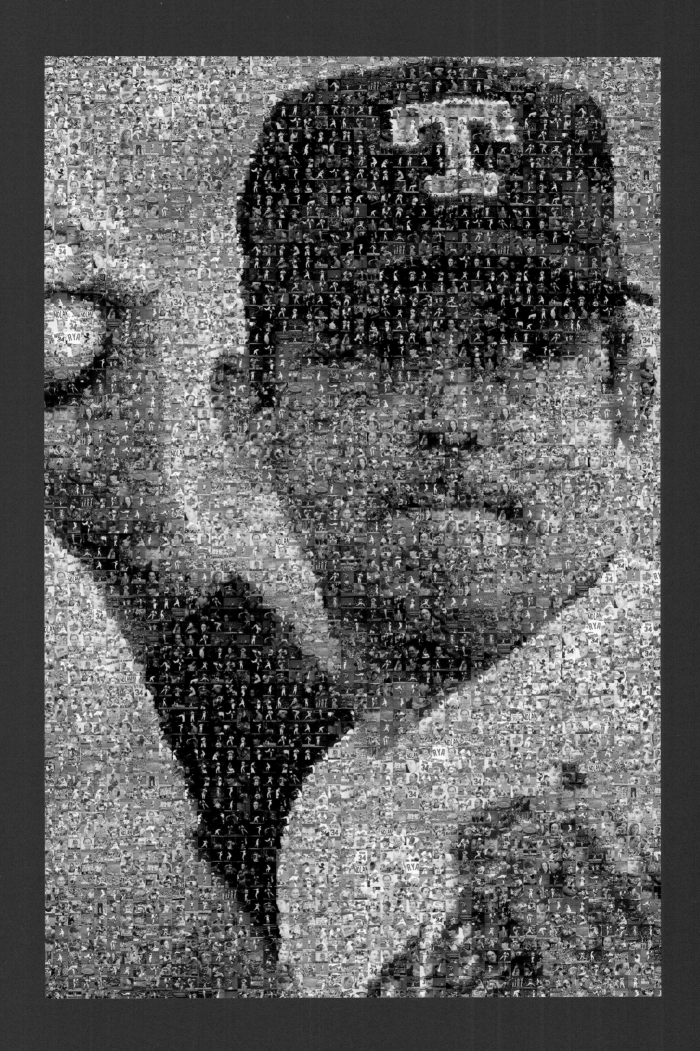

King Hussein bin Talal

MONARCH

At the time of his death on February 7, 1999, the reign of Jordan's King Hussein was among the longest of all active heads of state. For forty-seven years, he worked tirelessly to maintain a fragile peace between Jordan's Hashemite minority and its Palestinian majority, while building the economic and industrial infrastructure of a modern nation practically from scratch. Perhaps because Jordan is wedged precariously between Israel, Syria, and Iraq, Hussein was also a potent force for Middle East peace, both publicly and behind the scenes. His efforts culminated in the 1994 Jordanian–Israeli peace treaty, which formally ended forty-six years of war between the two nations.

In the summer of 1998, while King Hussein was undergoing cancer treatment at Minnesota's Mayo Clinic, a representative of Jordan's American-born Queen Noor contacted Robert Silvers about making a Photomosaic portrait of the king. Queen Noor had seen Silvers's Photomosaic of Princess Diana and wanted to create a similar tribute for her husband. She asked Silvers to make an image of Hussein from Jordan's land and people as well as significant events in the King's life. The finished piece was presented to His Majesty at the Mayo Clinic in December 1998.

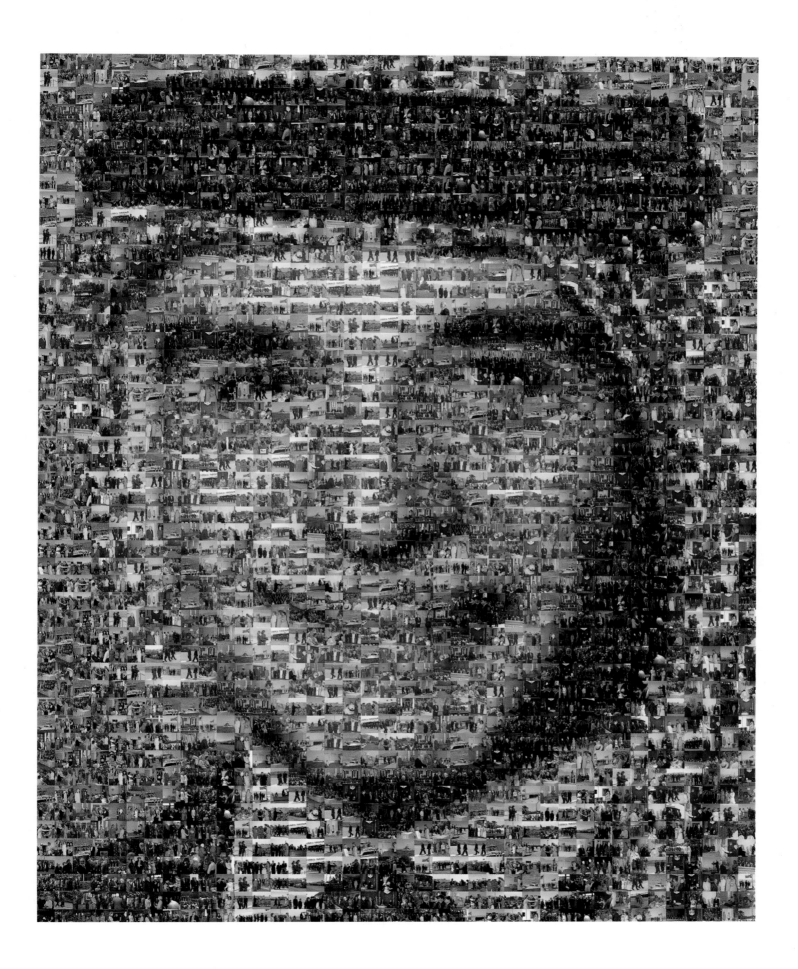

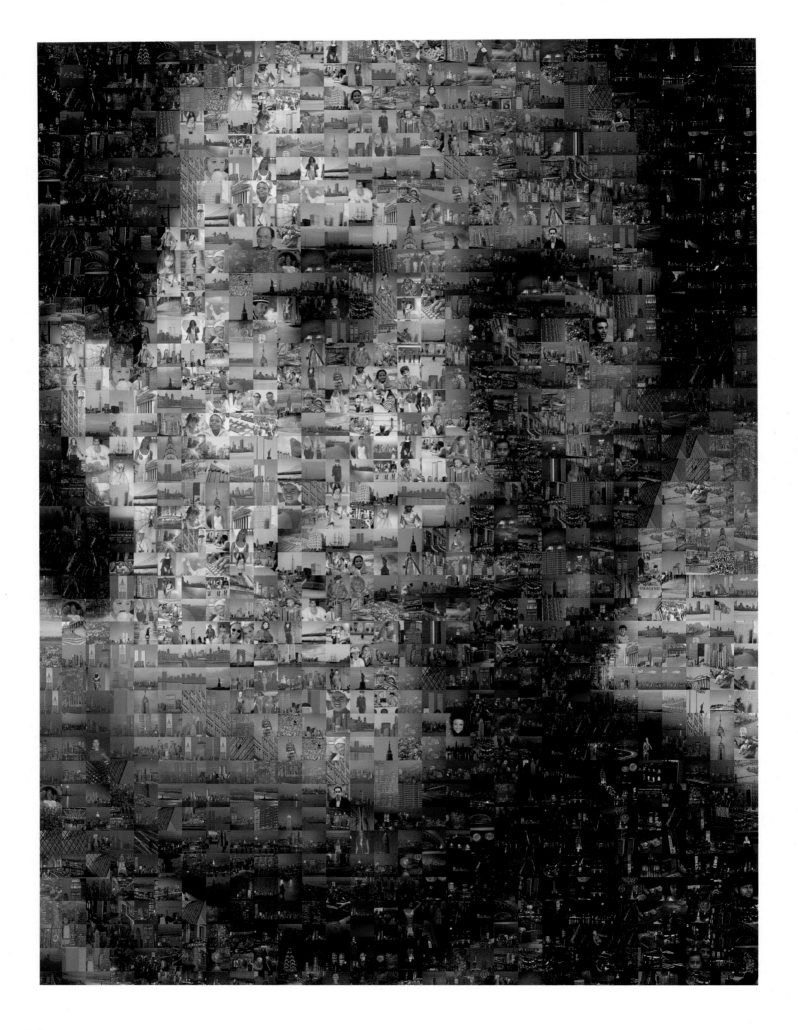

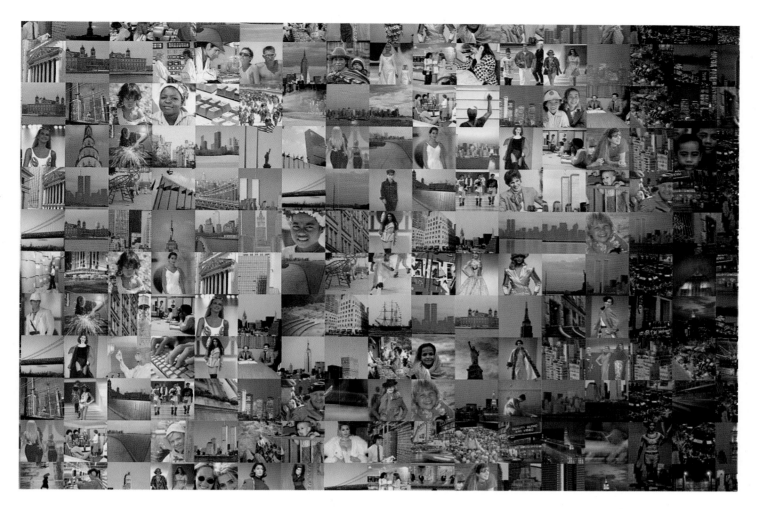

Jerry Seinfeld

COMEDIAN

In May 1998, *Total TV* magazine (and virtually every other publication in America) ran a "Good-bye Seinfeld" cover package celebrating the fabulously successful nine-year run of America's favorite water-cooler show. As a New York-based publication, *Total TV* (now *C* magazine) wanted to stress the local connection, so this portrait of New York's favorite son is crafted from quintessentially New York scenes, including the George Washington Bridge, the World Trade Center, lots of fashion shots, and plenty of Manhattan skylines.

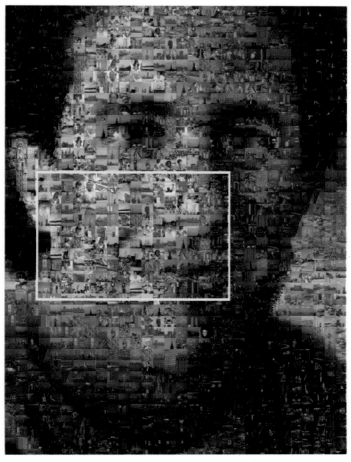

Jim Carrey

During the 1980s Jim Carrey rose to fame as a lunatic physical comedian on the television sketch-comedy program *In Living Color.* He reached superstar status in the mid-'90s when three Carrey vehicles, *Ace Ventura: Pet Detective, The Mask,* and *Dumb and Dumber,* all rocked the box office. In 1998, Carrey asserted himself as a more serious actor in *The Truman Show*, for which he recieved a Golden Globe Award. The poster for *The Truman Show*, made from hundreds of still images shot on the set, is one of Robert Silver's most widely recognized works.

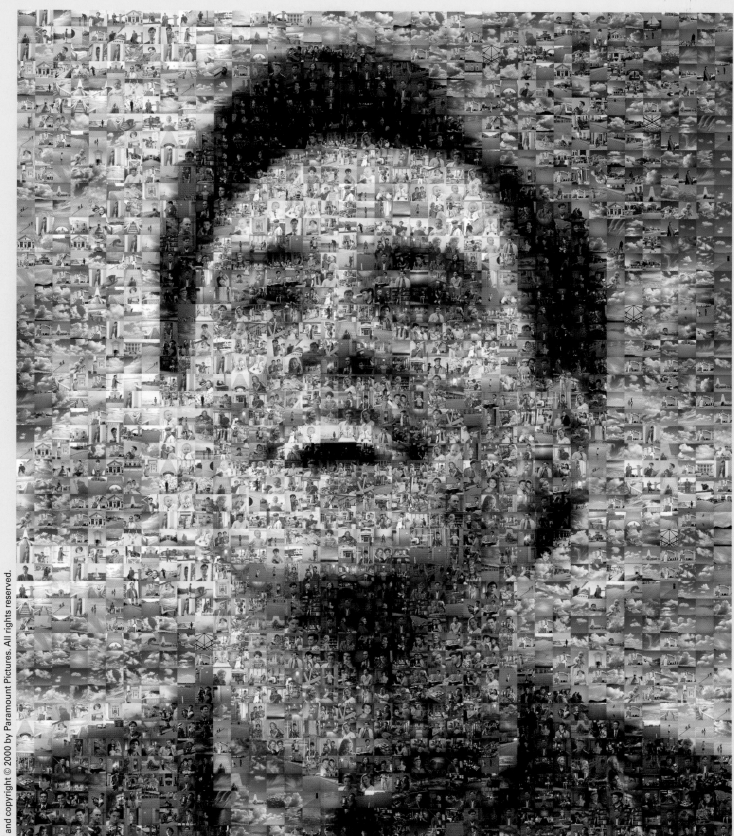

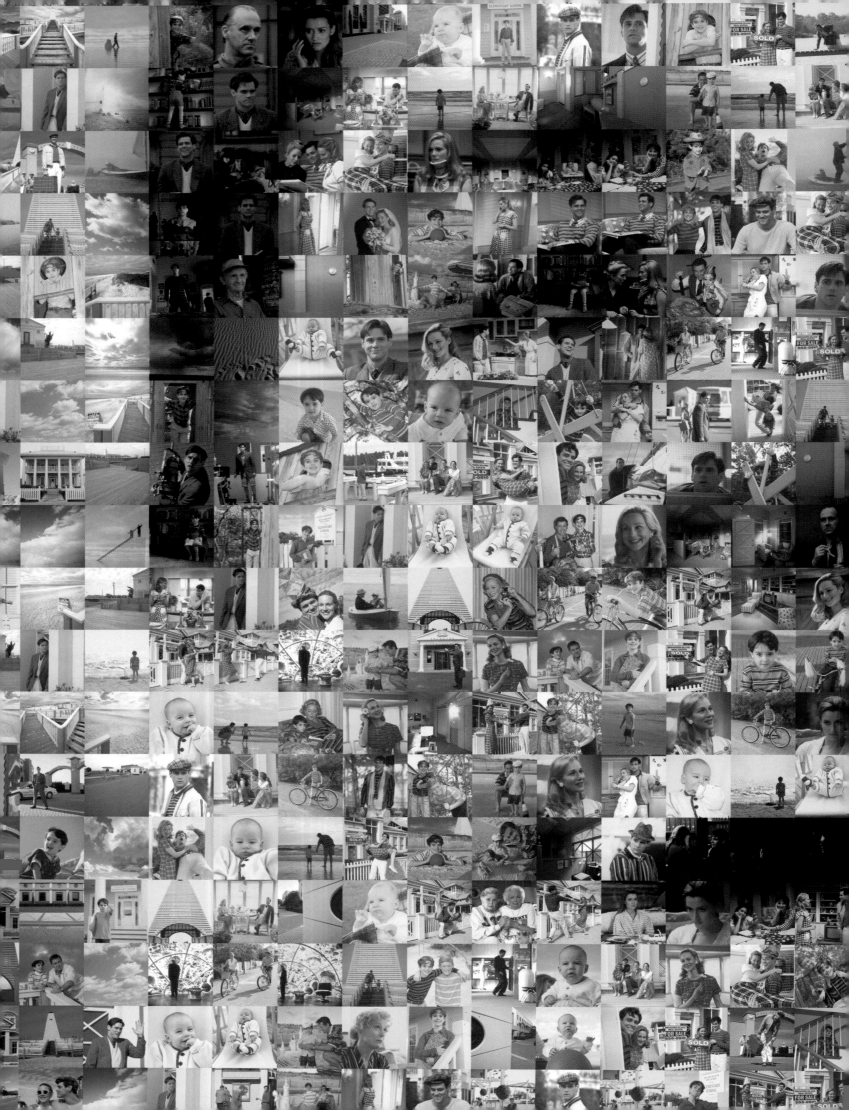

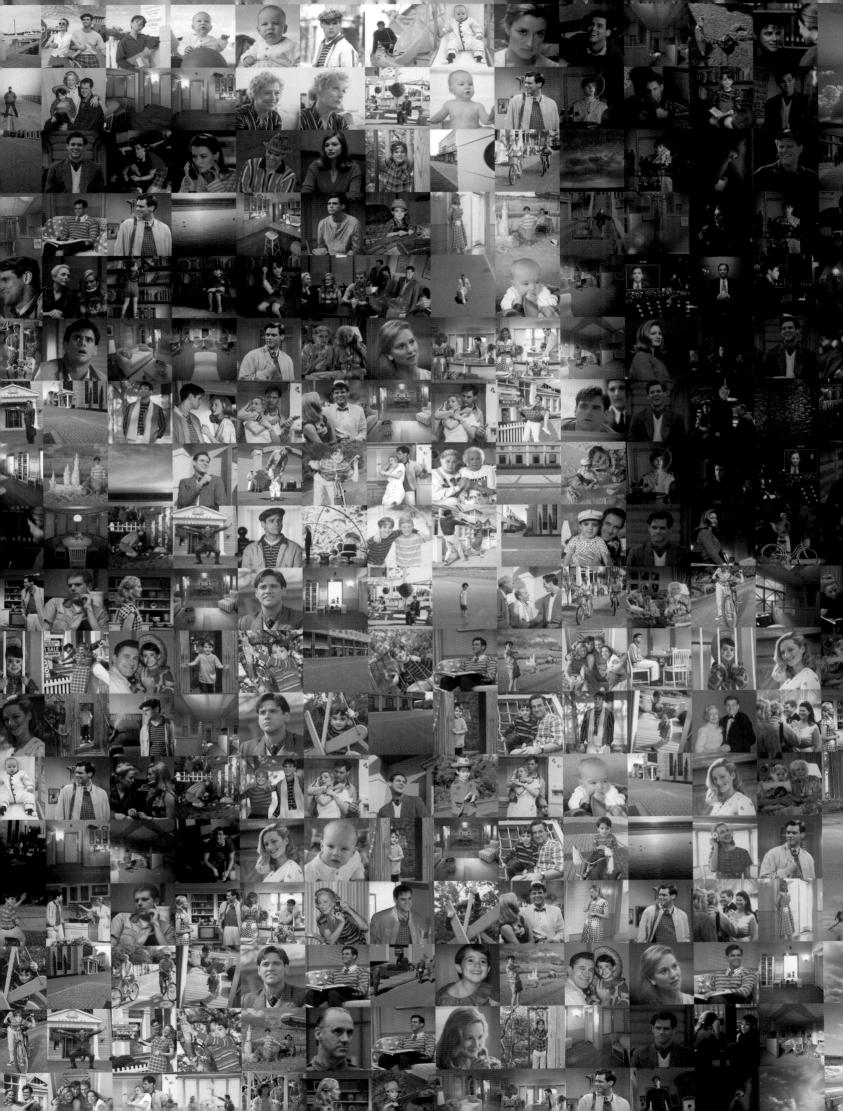

Tiger Woods

GOLFER

While Tiger Woods's accomplishments as a golfer rank him among the greatest ever to play the game, these accomplishments combined with his youth and minority background have forever changed the face of the sport. Woods became a professional at age twenty-one after winning three U.S. Amateur Championships. In 1997, he became the youngest player ever to win the PGA Masters Tournament (twenty-one years, three months, and fourteen days). Two years later he became the youngest to win the PGA championship. Those five major championships by age twenty-three matched Jack Nicklaus's total at the same age. Woods was named Sportsman of the Year by *Sports Illustrated* in 1996, Male Athlete of the Year by the Associated Press in 1997 and 1999, and PGA Player of the Year in 1997 and 1999.

This Photomosaic portrait was commissioned by *Sports Illustrated* for the cover of a special golfing issue. Robert Silvers used photographs of other professional golfers for most of the tiles. Look for pictures of Woods himself, his parents Earl and Kultida, Stanford teammate Notah Begay III, Nancy Lopez, Johnny Miller, Jack Nicklaus, Greg Norman, Mark O'Meara, Se Ri Pak, Arnold Palmer, and Payne Stewart. There are also glimpses of some of the famous greens and fairways that Woods has dominated since turning pro.

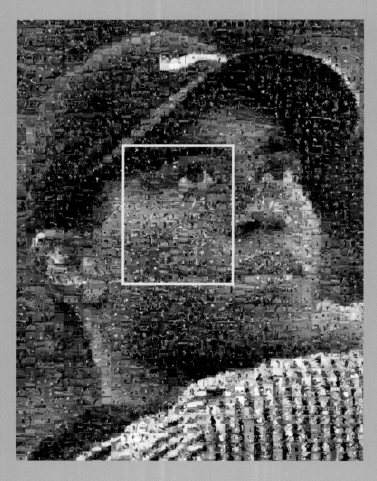

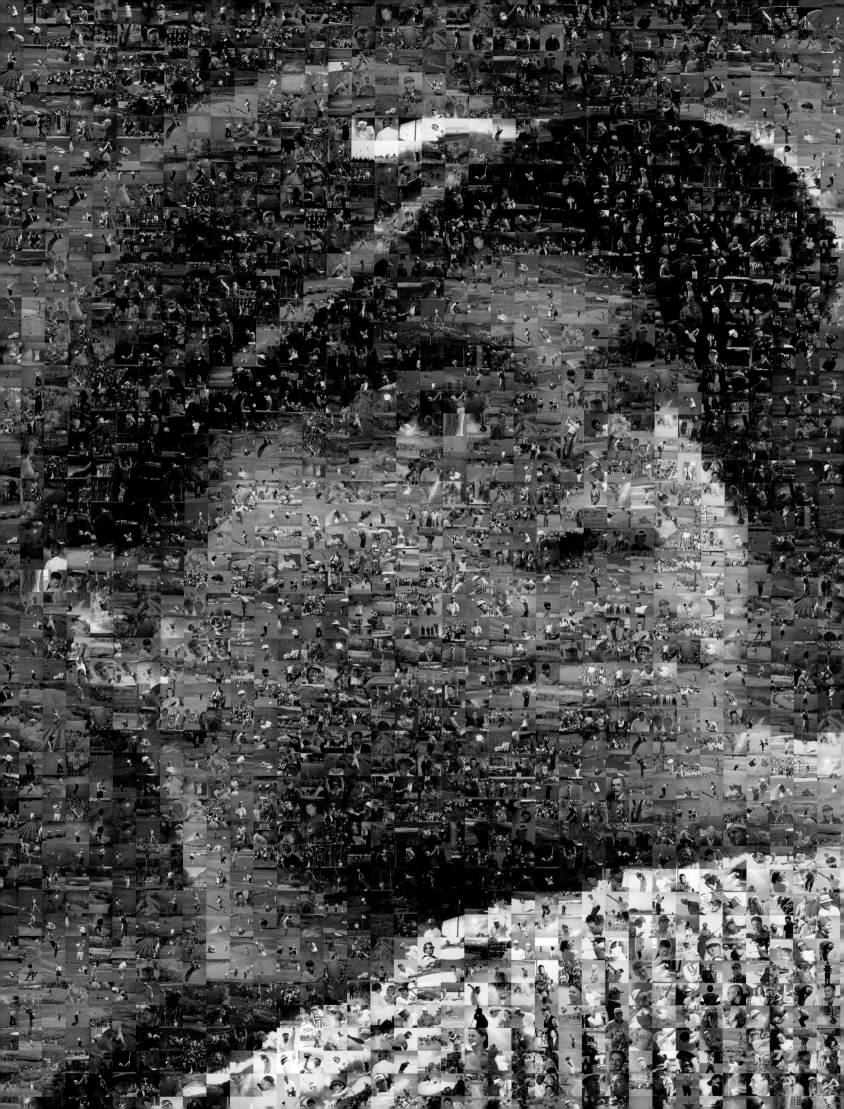

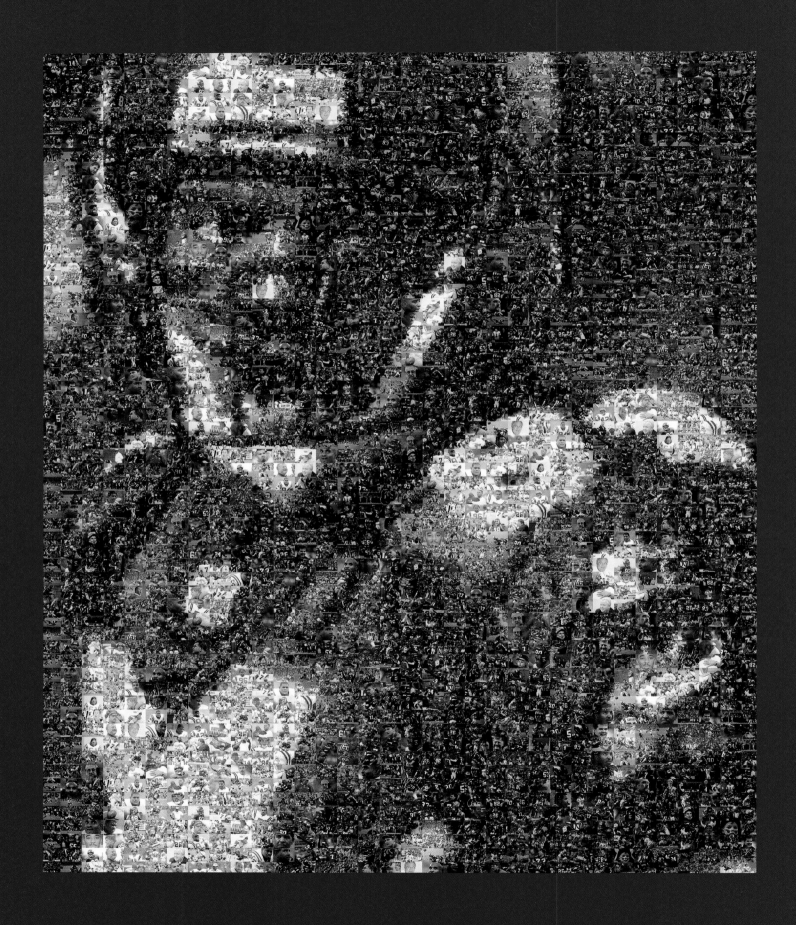

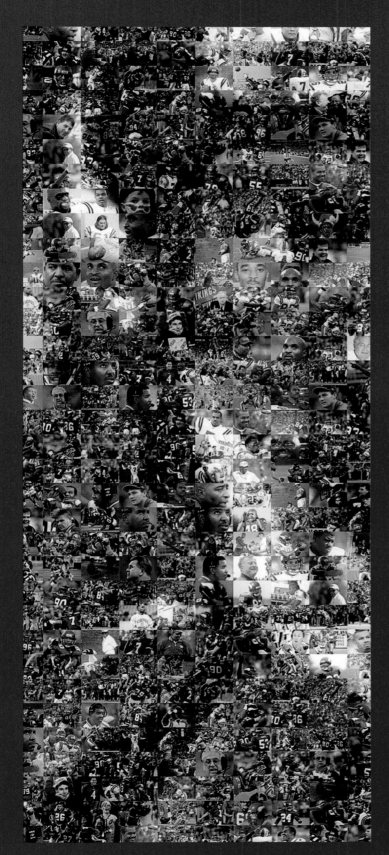

Randy Moss

During his rookie year with the Minnesota Vikings in 1998, Randy Moss gained 1,313 receiving yards and scored seventeen touch-downs, an NFL rookie record. Far and away the league's most captivating young player, Moss was named the National Football Conference's Rookie of the Year while claiming similar honors from publications such as *Sports Illustrated*, *The Sporting News*, *Pro Football Weekly*, and *Football Digest* among others. Moss was also the only rookie to earn a trip to the 1998 Pro Bowl.

Nearly everyone expected the Vikings to represent the NFC in the Super Bowl that year, including the *St. Paul-Pioneer Press*, which commissioned this image as the cover of its special Vikings Super Bowl section. When an inspired Atlanta Falcons squad upset the Vikings in the 1998 NFC championship game, the Moss Photomosaic was retired for the season and re-emerged as the cover of the *Pioneer Press*'s 1999 Vikings preview section.

The tiles in this image include photographs of Moss, his teammates, Coach Dennis Green, Vikings fans, and the occasional glimpse of an opponent such as then-New Orleans Saints Coach Mike Ditka.

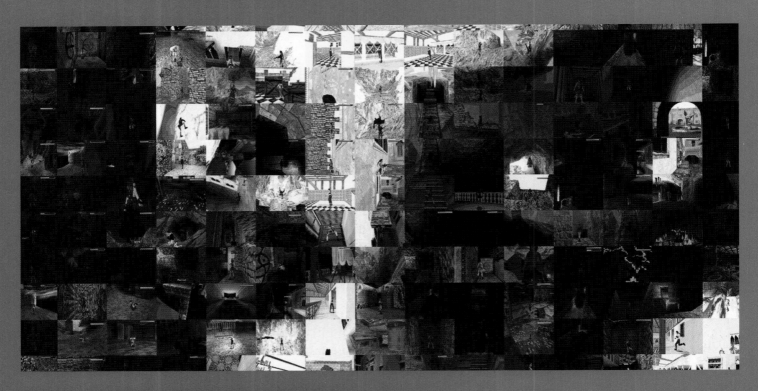

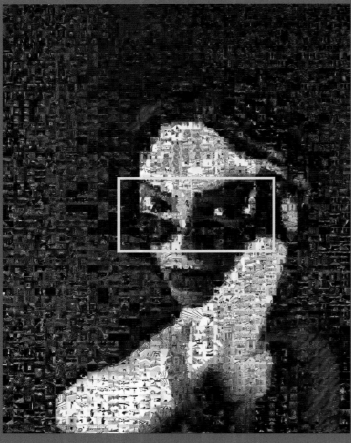

Lara Croft

Millions of teenage boys have battled their way through dark caves and musty catacombs in the company of the wildly intrepid and impossibly curvaceous British aristocrat Lara Croft. Croft, of course, is the digital heroine of Sega's Tomb Raider video games and the subject of countless Web sites, chat rooms, and adolescent fantasies. This Lara Croft Photomosaic, made from more than one thousand Tomb Raider screen grabs, was commissioned for the September 1998 issue of *Electronic Gaming Monthly*.

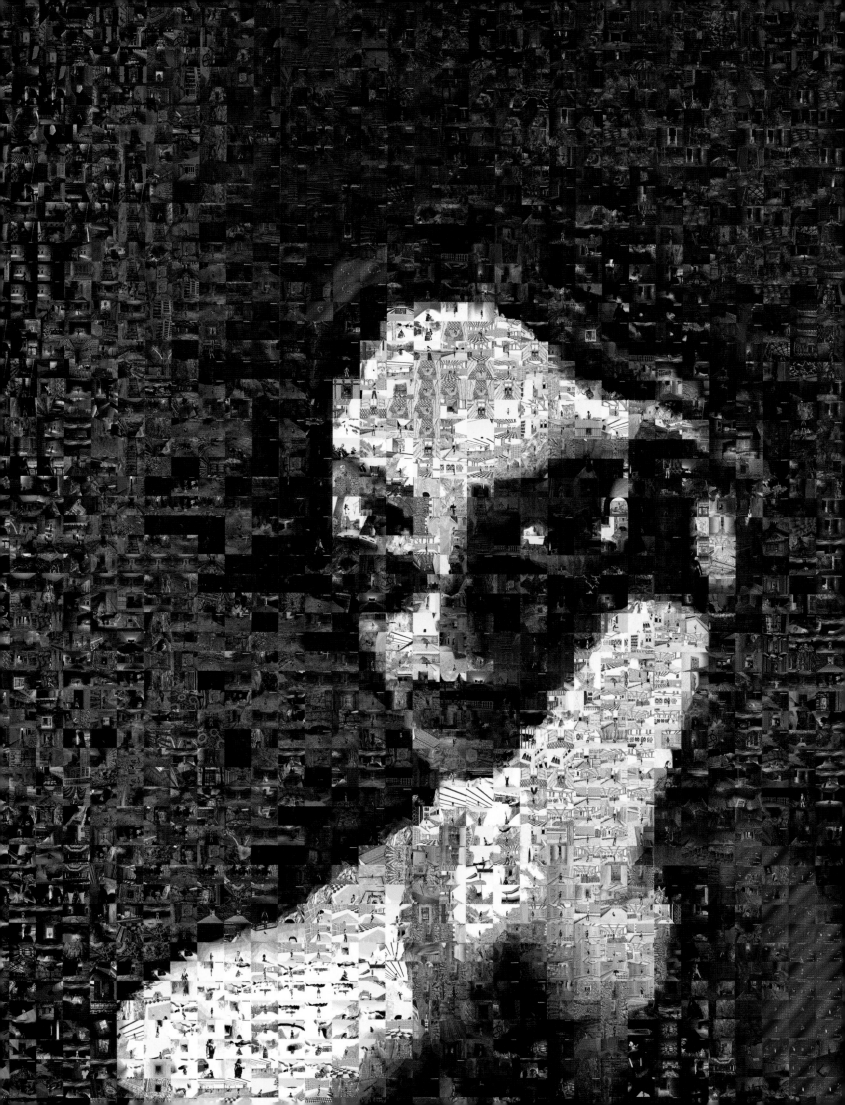

Credits

Jesus Christ — Concept of creating Jesus Christ from the Dead Sea Scrolls proposed by Edward Lewis. Created for the Jesus 2000 contest held by the *National Catholic Reporter.*

Benjamin Franklin — Commissioned by *The American Benefactor*, cover fall 1997. Based on a Benjamin Franklin portrait by Charles Wilson Peale/Smithsonian Institution. Component tiles are from the author's database.

Jack Daniel — Courtesy of Jack Daniel's Properties, Inc. JACK DANIEL'S and OUR BENEV-OLENT SPONSOR are registered trademarks of Jack Daniel's Proper-ties, Inc., and are used under license to Penguin Putnam Publishers. Jack Daniel's portrait courtesy of Brown-Foreman Corporation. Creative concept by Simmons-Durham. Thanks to Ruth McKinney.

George Eastman — Courtesy of the George Eastman House. Base image and component tiles are from the George Eastman House Collection. Thanks to Rick McKee Hock.

Wright Brothers — Based on a photograph from the Dayton and Montgomery County Public Library collection. Component tiles are from the author's database.

Albert Einstein — Scientific images are from the author's database.

Babe Ruth — Reproduced by special permission of The Walt Disney Corporation. Copy-right © 1999 by The Walt Disney Corporation. Special thanks to the ESPN Zone, Steven Diamond, Flor Wickham, and Danny Schmider.

Migrant Mother — Based on a photograph by Dorothea Lange. Composed of selected Farm Security Administration photographs from the Prints and Photographs Division, Library of Congress National Digital Library Program.

Eleanor Roosevelt — Base image and component tiles are from the Franklin D. Roosevelt Library and Digital Archives.

Marilyn Monroe — Reproduced by special permission of *Playboy* magazine. Copyright © 1998 by Playboy. Used with permission, all rights reserved.

King Hussein bin Talal — Base image and component tiles provided by Her Majesty Queen Noor Al-Hussein of Jordan.

Mao Zedong — Base image and component tiles are from the author's database with addi-tional photos provided by David Nagy.

Jack Nicklaus — Courtesy of Nicklaus Golf Equipment. Base image and component tiles are from *Sports Illustrated*. Component tile photos by Jacqueline Duvoisin, Mel Digiacom, John Iacona, Walter Iooss, Jr., James Drake, Heinz Kluet-meier, and Eric Schweikard.

Ahmet Ertegun — Courtesy of Atlantic Records and Ahmet Ertegun. Special thanks to Leila Logan.

Richard Nixon — Courtesy of *Esquire* magazine. Special thanks to Rockwell Harwood, art director. Component tiles are from Corbis Sygma Photos.

Bob Marley — Courtesy of GB Posters and the Estate of Bob Marley. Thanks to Max Arguile.

Pope John Paul II Based on a photograph provided by the Apostolic Nunciature, Washington, D.C. Component tiles are from the author's database.

Diana, Princess of Wales Based on a photograph provided by the Alpha/Globe agency. Component tiles are from the author's database.

Arnold Schwarzenegger Courtesy of *Muscle and Fitness* magazine, Weider Publications, Inc., and Arnold Schwarenegger.

Michael Jordan Courtesy of *Sports Illustrated for Kids.* Thanks to Sheryl O'Connell and SFX Entertainment.

Oprah Winfrey Reproduced with permission of HARPO Productions, Inc.

Claudia Schiffer Originally published in *Allure.* Thanks to Clio McNichol.

Tim Berners-Lee Courtesy of *Time* magazine. Based on a photograph by the author. Thanks to Jay Colton.

Nolan Ryan Courtesy of the *Fort Worth Star-Telegram.* Thanks to Joyce Marchall.

Jerry Seinfeld Commissioned for the cover of *Total TV* for the last episode of *Seinfeld.* Thanks to Robert Edelstein, *C* magazine.

Jim Carrey Courtesy of Paramount Pictures.

Tiger Woods Courtesy of *Sports Illustrated.*

Randy Moss Courtesy of *St. Paul-Pioneer Press.* Thanks to Sue Campbell.

Lara Croft Courtesy of *Electronic Gaming Monthly.* Thanks to Cyril N. Wochok.

Rob Silvers Based on a photograph by Enver Hirsch. Produced for *Die Zeit* magazine. Retouching by Ché Graham.

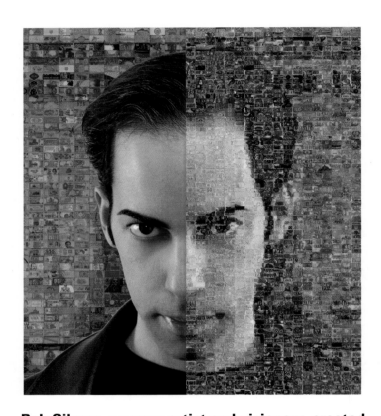

Rob Silvers, a young artist and visionary, created groundbreaking new technology that changed the nature of art, photography, and computer graphics. Silvers earned his Master's Degree in Media Arts and Sciences from the MIT Media Lab, where in addition to inventing Photomosaics, he worked with digital photography and holographic portraits. He is currently the President and CEO of Runaway Technology (www.photomosaic.com). His previous books include *Photomosaics* and *Disney's Photomosaics.*